STAR WARS

ON THE FRONT LINES

TITAN
BOOKS

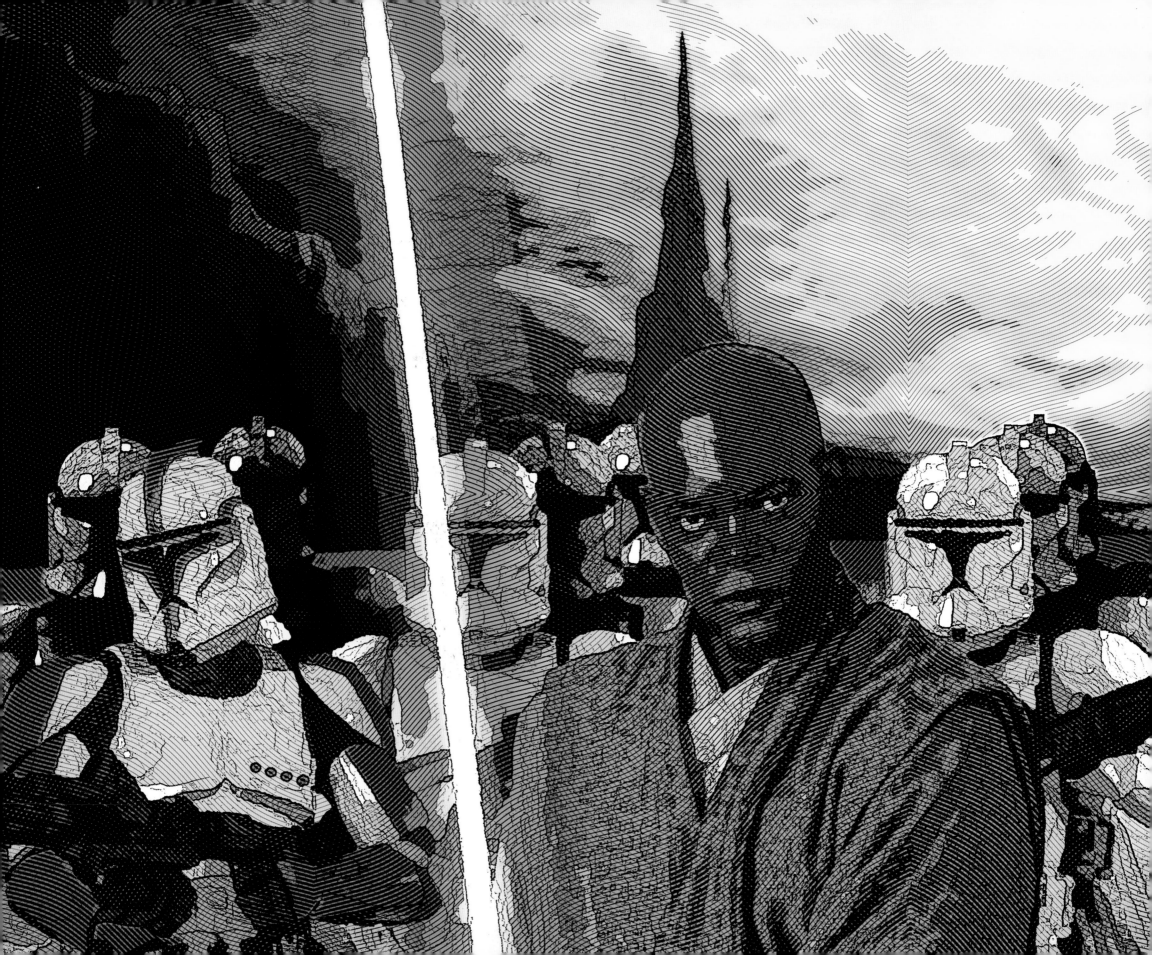

STAR WARS™

ON THE FRONT LINES

BY DANIEL WALLACE

TITAN BOOKS

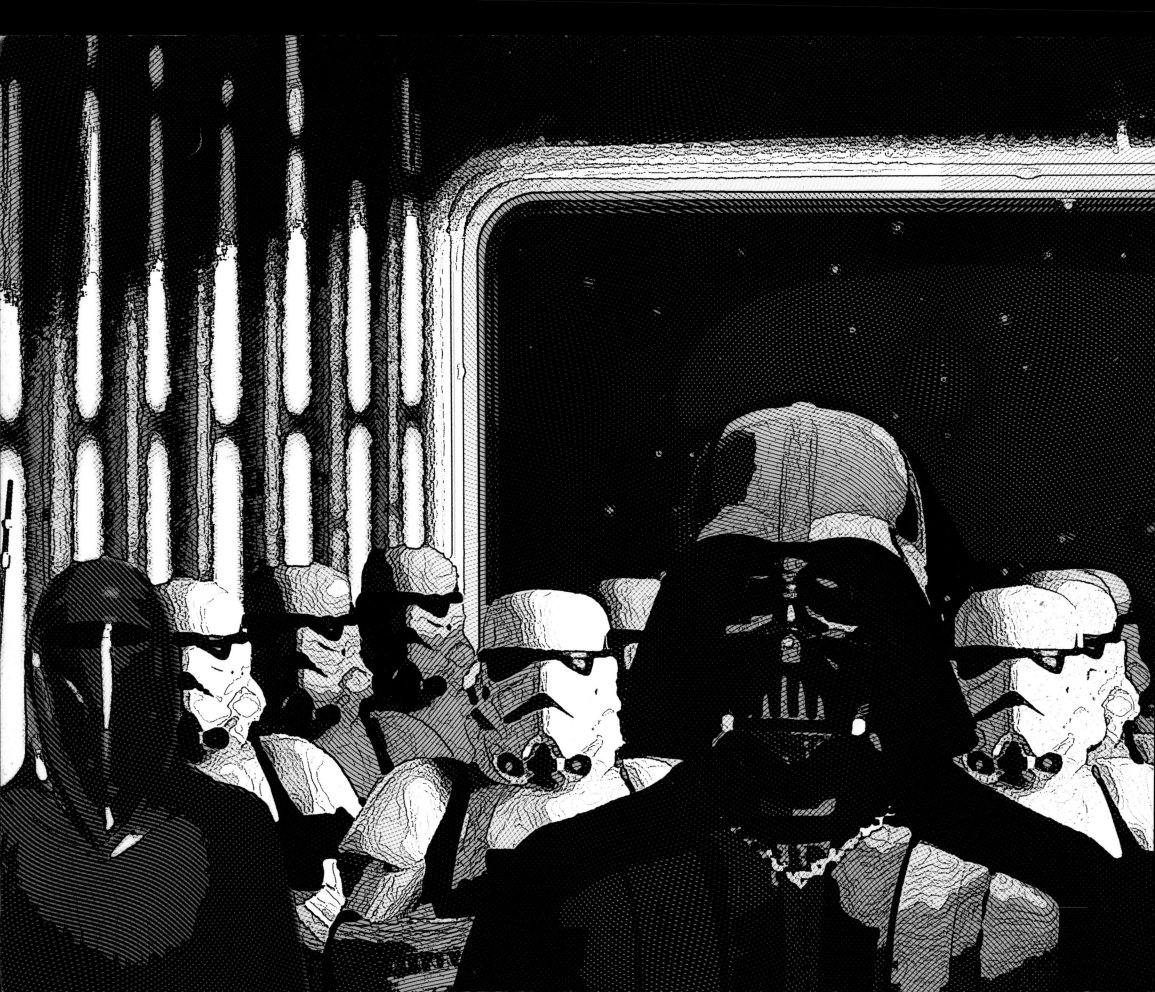

CONTENTS

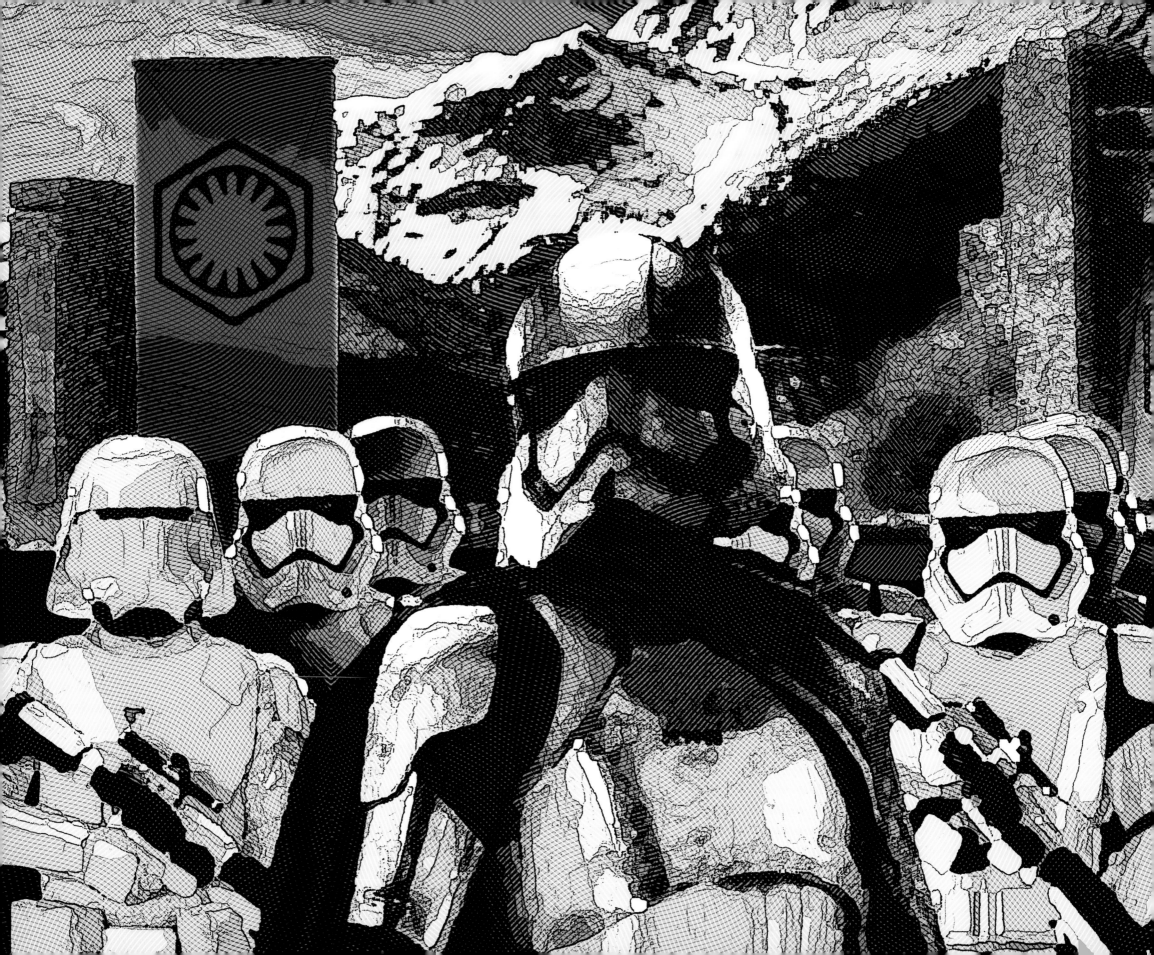

INTRODUCTION

Faster-than-light hyperspace travel connected star with star, culture with culture. Trade and cooperation followed. So did conflict.

War on an interstellar scale defined the galaxy's political borders: the magisterial sweep of the Tion, the lawless lump of Hutt Space, the veiled enclave of the Mandalorian worlds. Many borders still exist as millennia-old scars.

The Galactic Republic sought to end war by uniting nearly all civilized planets under one banner. Disputes under the Republic would be settled through arbitration and debate. There would be no need for violence.

The goal was noble, but the Republic fell short in its ideals. Corruption and endless political dithering provided plenty of ammunition for an ideologue like Senator Sheev Palpatine to propose a new government. One with stronger centralized power, for example, where leaders could take direct action. One with a powerful military to protect its citizens and ensure peace for tomorrow. An Empire.

Palpatine couldn't sell his idea without making the costs of war apparent to all. His rigged conflicts—one at Naboo and hundreds during the Clone Wars—drove home combat's ugly reality. The soldiers who fought these battles believed in their cause and never suspected that they were pawns of war, being sacrificed for a political end.

Thus came the Empire. For a time there was a form of peace. But unrest grew into the Rebel Alliance, who believed peace through coercion was not worth defending. They took up arms against the Empire's authoritarianism. At Scarif, Hoth, Endor, and Jakku, liberty and tyranny ebbed and flowed.

The rise of the First Order was evidence that despots will always have their defenders. In the face of such threats, sometimes the only choice is to stand and fight.

Battles have determined the rise and fall of great galactic powers, but no battle can be understood from a distance. Insight only comes when you've experienced a view from the front lines.

PART I

THE CLONE WARS

THE REPUBLIC existed free of widespread war for untold years, but it was a troubled sort of peace. The Galactic Senate had been rendered useless by competing interests and rampant corruption. The elevation of interstellar corporations into actual voting bodies only made the situation worse.

Senator Palpatine of Naboo sensed the people's hunger for achievement, not compromise. The Clone Wars—beginning with a prelude on Naboo—were the fruit of Palpatine's breathtakingly ambitious plan to wipe out the Jedi and bring down the Republic. His allegiance to the dark side of the Force and his double identity as the Sith Lord Darth Sidious remained undetected by the Jedi until it was too late to stop him.

In the hands of Palpatine, war was a tool that polished his image and annihilated his opponents. It only took a decade for him to achieve utter domination.

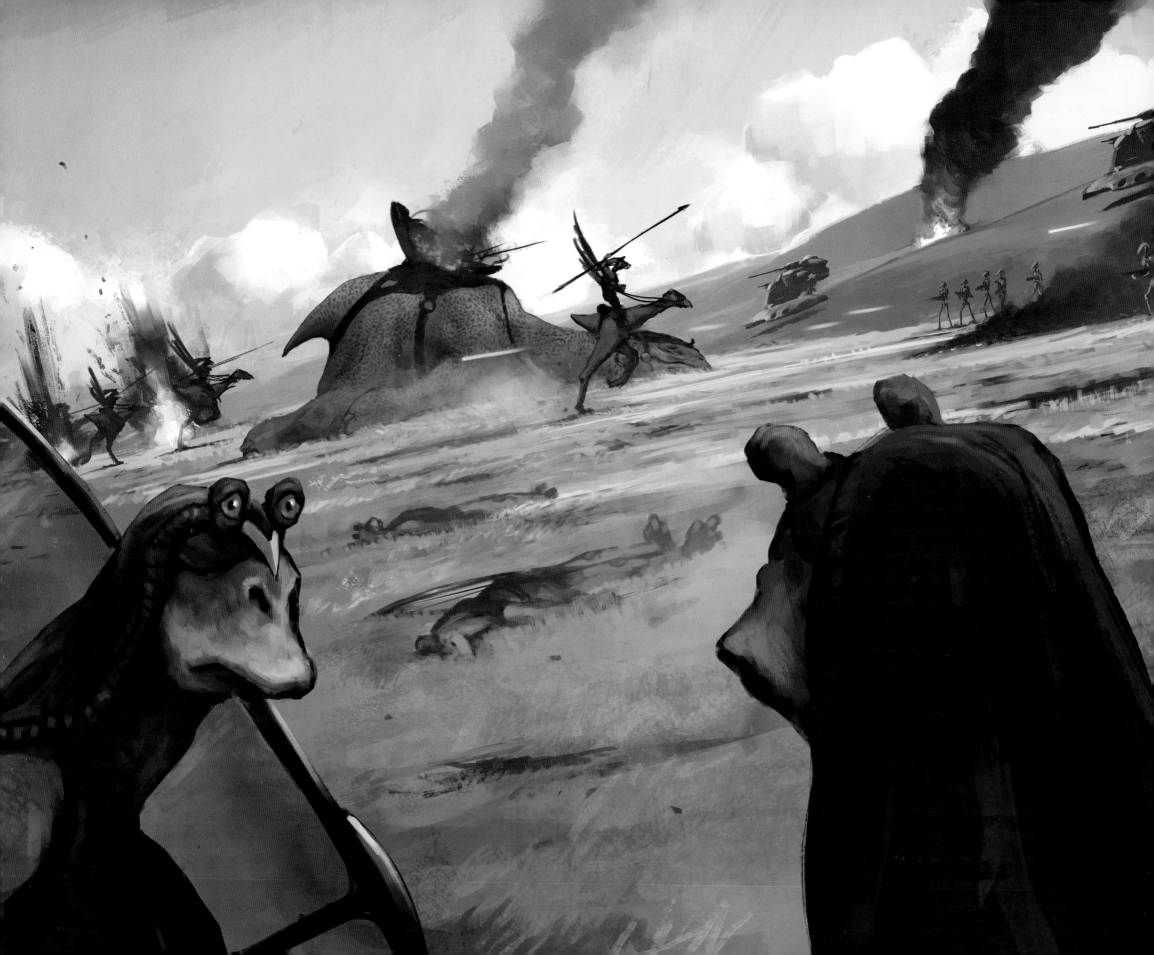

BATTLE OF NABOO

- GROUND -

At the time, the Trade Federation's invasion of the unassuming Mid Rim world seemed to be a minor dustup—notable more for the debates it engendered in the Galactic Senate than for the conflict itself.

Yet had this showdown between the authority of the Republic and the reach of the Trade Federation not occurred, the galaxy might have been spared the many wars to come. The battle laid bare the Republic's most glaring flaws—a weak central authority, a labyrinthine bureaucracy, and a nonexistent military—and did so on a galactic stage. No one could deny the Republic's failings, nor could they deny Palpatine his role as crusading reformer. After this event, every anti-Republic speech referenced the "debacle at Naboo," with both the Trade Federation and the old-guard leadership of Chancellor Valorum bearing the brunt of the blame.

Without the Battle of Naboo, Palpatine would not have become Supreme Chancellor and encouraged the vilification of corporate conglomerates that led to the Separatist movement. Although it predated the war by a full decade, the Battle of Naboo was in many ways the first spark of the Clone Wars.

GENERAL CEEL

The leader of the Gungan Grand Army, Tobler Ceel was a close friend and former comrade-in-arms of Gungan chieftain Boss Nass. General Ceel had the most battlefield experience among the high-ranking members of the officer corps, including last-minute appointee General Binks.

PRELUDE TO BATTLE

Outraged by Republic taxes levied on trade routes, Trade Federation viceroy Nute Gunray blockaded Naboo to draw the attention of the galaxy and use the spotlight to demand government concessions. His choice of target came at the suggestion of Darth Sidious, a shadowy figure who had orchestrated Gunray's rise to the top. Unknown to all players was Sidious' double identity as Naboo's Senator Palpatine, who plotted to use his people's plight in a bid for political sympathy.

At Sidious' urging, Gunray escalated the conflict by invading Naboo with battle droids, intending to force a sham treaty upon the young and inexperienced Queen Amidala. The Queen's escape and subsequent speech before the Galactic Senate, however, resulted in the ousting of Chancellor Valorum—and the election of Senator Palpatine as his replacement.

Meanwhile, Queen Amidala and her entourage returned home to free her people by any means, including force.

TACTICAL ANALYSIS

With her loyalist forces vastly outnumbered by the Trade Federation's battle droids, Queen Amidala determined that a surgical strike on the Theed Royal Palace could result in the capture of Viceroy Gunray and an end to the occupation. To draw the enemy away from her target, Amidala formed an alliance with Boss Rugor Nass and the indigenous Gungans, who had their own grudge against the Trade Federation following a string of attacks on their underwater settlements.

The Trade Federation had forced nearly the entire population of Gungans to abandon their cities and relocate to a sacred enclave deep in the swamps. Messengers sent by Boss Nass spread word among the refugees that all able-bodied militiagungs were to report for duty. For the first time in years, the Gungan Grand Army—a patchwork assemblage of local defense forces pulled from each Gungan city—would assemble for battle.

On the Great Grass Plains forty kilometers south of Theed, the Gungan Grand Army prepared for a show of force. Assuming that Gunray took the bait and dispatched battle droids to meet the Gungans, the Queen and her strike team could use the diversion to break into a virtually undefended palace and force Gunray's surrender.

> "ON A SIGNAL FROM GENERAL CEEL, THE GUNGANS ACTIVATED SHIELD GENERATORS CARRIED ON THE BACKS OF REPTILIAN FAMBAAS."

Thousands of militiagungs emerged from the swamp and marched across the open plains. Confirmation of the Gungans' success as a diversion came with the first sighting of AAT tanks on the high ground of Shaak Ridge. On a signal from General Ceel, the Gungans activated shield generators carried on the backs of reptilian fambaas. A translucent bubble—nearly a kilometer from end to end—surrounded the waiting army.

Knowing that the Trade Federation couldn't penetrate the bubble by bombardment, the Gungan plan was a sustained, mutual standoff, lasting until he received confirmation of the viceroy's capture, at which point the Gungans could retreat back into the swamp under the safety of their shield.

At first, Trade Federation commander OOM-9 responded as expected by ordering a barrage from his AATs. When that proved ineffective at damaging the shield, OOM-9 brought in his MTT troop carriers.

Because the Gungans could not make long-range attacks inside their shield bubble, the Trade Federation unloaded its

full complement of B1 battle droids without incident. Jolted to life by the orbiting Droid Control Ship, the battle droids marched forward and breached the energy-resistant barrier. Once they cleared the membrane, the B1 battle droids opened up with close-range blaster fire.

The diameter of the energy shields created tight quarters and restricted the options available to the Gungans. Their catapults were best suited for long-range attacks, thus the Gungan generals ordered the front line to engage the battle droids with cestas and boomas, and redirected their catapults for less-effective short tosses. Dozens of battle droids crumpled under attack by the ionized plasma, but the fast-rolling droidekas soon opened holes in the Gungan line. Then one shield generator exploded, and the whole shield dropped.

With the loss of the shields, the Gungan army's plans for stalling dissipated, and OOM-9 swiftly brought the full brunt of his forces to bear. The loss of the shield, however, had one upside for the Gungans. No longer contained by their own barrier, their catapult crews were free to fire long-range lobs at the advancing AATs and MTTs.

The gutsy militiagungs damaged the Trade Federation's heavy equipment, but it wasn't enough to turn the tide. Their outnumbered battle formations began to break apart. With still no word from Queen Amidala, General Binks issued the order for a tactical retreat.

Isolated victories occurred across the field of battle. While clinging to a cannon barrel, General Binks unintentionally neutralized an AAT. But, as the fighting inevitably wound down, the remaining Gungans found themselves surrounded and held at blasterpoint.

> **"WITH THE DESTRUCTION OF THE ORBITING DROID CONTROL SHIP, EVERY TRADE FEDERATION DROID SWITCHED OFF AT ONCE."**

It was in that instant the distant battle raging above the planet turned the tide. With the destruction of the orbiting Droid Control Ship, every Trade Federation droid switched off at once—even OOM-9 was temporarily inactive.

The abrupt stroke of good fortune brought victory. The Gungan Grand Army had won.

AFTERMATH

To honor the sacrifice made by the Gungans on the Great Grass Plains, Amidala and Boss Nass forged a pact between their two civilizations and pledged to work together toward a new era of openness and cooperation.

The treaty that united the Gungans and the people of Naboo saw immediate benefits. New lines of trade opened, bringing low-cost medicinal herbs to the citizens of Theed and machined parts used in seawater pumps to the engineers of Otoh Gunga. Some Gungans even relocated to sell their goods in the surface settlements. Old habits died hard, however, and within a year most of the cross-cultural exchange had quietly ceased.

In the days that followed the battle, a parade through Theed and a ceremony on the palace steps marked the occasion. Supreme Chancellor Palpatine made an appearance at the victory celebration, leveraging the events on Naboo to reassure Republic citizens that he deserved his new post. Unlike Valorum, Palpatine promised to be a leader who took action and got results.

With the powers of the chancellorship now open to him, Palpatine began moving more pieces into place. A decade later he would have the war he desired.

OOM-9

Designated as a commander by dull yellow markings and an enhanced cognitive and tactical module, OOM-9 scored early victories in the invasion of Naboo by pacifying Theed and conquering the Gungan underwater cities.

COMBATANTS

1 **BATTLE DROIDS:** Flimsy, cheaply manufactured mechanical soldiers produced by the Geonosians, B1 battle droids obeyed a central command signal beamed to the surface from an orbiting Trade Federation battleship.

2 **DROIDEKAS:** Also known as destroyer droids, these rolling monstrosities came equipped with double-blaster cannons at the end of each arm and deflector shield generators. The Trade Federation, reluctant to pay top cost for droidekas, used them sparingly.

3 **MILITIAGUNGS:** Service in the Gungan Grand Army was a noble calling among the Gungans, and most adults spent some time as members of their city's militia. Until the Battle of Naboo, the army's function was mostly to contain dangerous wildlife.

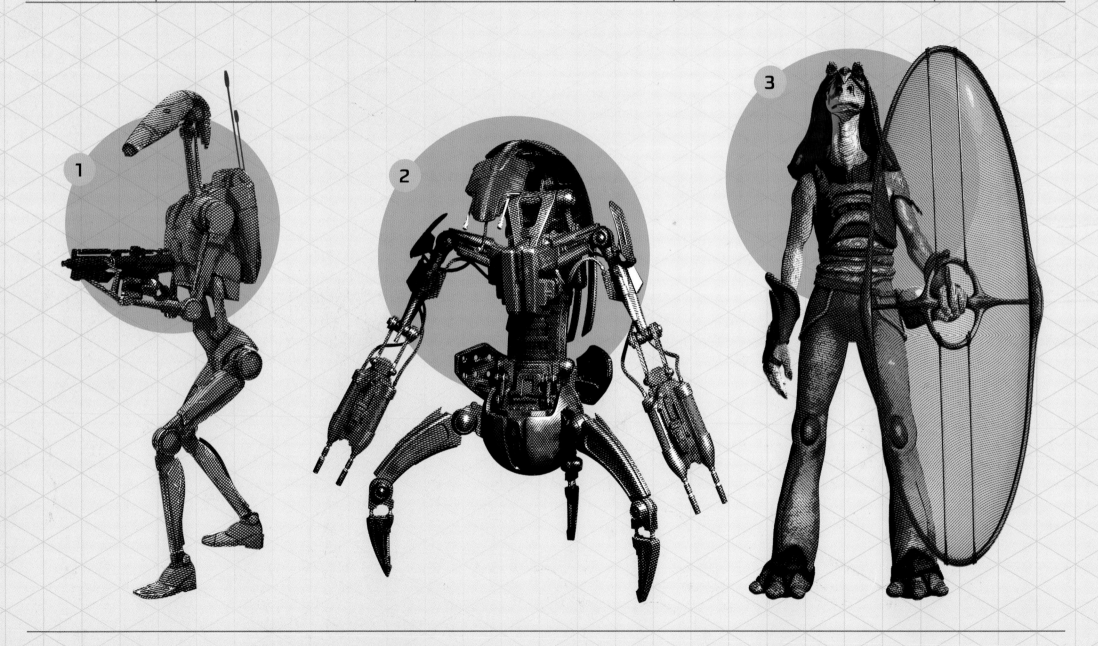

Oma Prumba, militiagung conscript

NABOO

Otoh Langua was just a litta bitty city, but the mackineeks hit it anyway. They chased us militiagungs from Langua all the way to the Boss Meetup in the Sacred Place. That was where the Gungans made plans to fight back. Mesa ready, but also plenty scared.

Theysa put us into the regiment serving under General Binks. It was his first day as a general. That didna make me feel very bombad.

But something happened with Binks. Something nutsen. The mackineeks came at us, and the general got one tangled all up on his foot. Every time he stompda, the mackineek

zapped its flasher and broke up more mackineeks. Then the general tried to swing a cesta, but it flew out of his hands and somehow it knocked a mackineek's head clean off. Then the general spilt a wagon of boomas down the hill, booming up a whole unit of mackineeks.

We started thinking that he'd been gifted by the guds. And so, mesa and the rest, we thought mayhap that all of that had rubbed off on us too. Wesa puttin a whole sack of boomas into a catapult and, without even aiming, we lettin it fly. That sack sailed right down the hatch of a droid tank and popped it open like a boiling hohokum.

So next, wesa free the reins of a fambaa. That fambaa charged right at the enemy and started crunchen mackineeks with every step.

Finally the mackineeks gottin us surround, but mesa and the rest, we just looked at each other, smiling. We was going to rush them. We didn't care about their flashers. We just had a feeling that we'd like seeing what we could be doing. And that's when the mackineeks switched off.

Thinking on it, was we all just mooie-mooie lucky? Maybe we was.

But mesa liken to believe it was destiny.

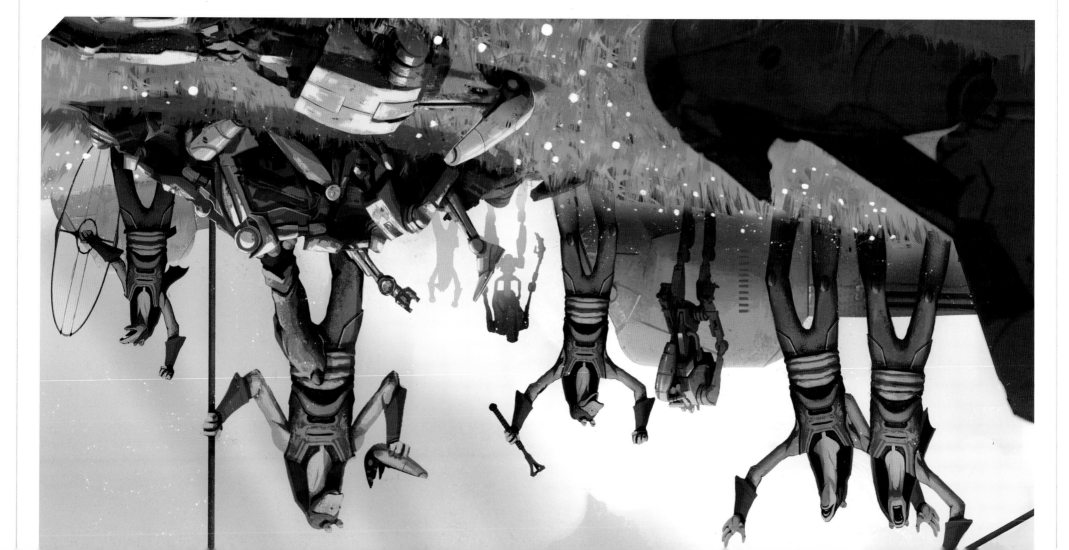

Tales of Valor

Captain
Roos Tarpals

A career military veteran, Roos Tarpals served as patrol chief of Otoh Gunga when the armed conflict broke out with the Trade Federation. From his position on the city's perimeter, Tarpals sounded the alarm warning of the battle droid attack and coordinated the evacuation of the Gungans to the safety of the swamps. Based on Tarpals's actions, some officers in the Gungan Grand Army expected Boss Nass to promote him on the eve of the historic attack. Instead, the impulsive chief bestowed that honor to a civilian: Jar Jar Binks.

Unfazed and unflappable, Captain Tarpals continued in his duty. He requested to serve under General Binks to advise the new officer and better safeguard the troops under his command. During the standoff on the Great Grass Plains, Tarpals realized the inevitability of bloodshed when the enemy battle droids shouldered their way through the shield's plasmic barrier. His rueful comment (according to observers): "Ouch time."

Captain Tarpals did everything in his power to delay the Trade Federation advance. Astride his kaadu, he raced across the battlefield, keeping General Binks's forces gelled into a fighting unit, despite the chaos of battle and the random element provided by Binks himself. He is credited with sixteen battle droid kills, many of them cut down in the act of taking aim at General Binks. In fact, Tarpals's unremarked role in keeping the general safe is the main factor behind Binks's reputation for divine invincibility.

TOOLS OF WAR

1 AAT: The Baktoid Armored Assault Tank was a heavily armed repulsortank with a reinforced nose, allowing it to smash barricades. In addition to its heavy cannon, it carried light laser cannons and six launch tubes for energized projectiles.

2 MTT: Designed specifically to ferry B1 battle droids into combat zones, Baktoid's Multi-Troop Transport could carry up to 112 folded battle droids on its internal racks. Four antipersonnel blasters provided defense.

3 STAP: The Single Trooper Aerial Platform was a fast, nimble flier built for a single occupant and was equipped with a dual blaster cannon. The Trade Federation employed STAPs for battlefield reconnaissance.

4 FAMBAA SHIELD GENERATOR: Gentle giants, fambaas were swamp-dwelling herbivores that could reach nine meters in height. The Gungans trained fambaas to carry heavy shield generators into battle, where the generators could be linked to project an energy shield impervious to high-kinetic assault.

5 GUNGAN BOOMA: Balls of various sizes packed with explosive plasma, boomas were the primary armament of the Gungan Grand Army. They could be thrown with slings, cestas, atlatls, and heavy catapults.

6 GUNGAN KAADU MOUNT: Kaadu were two-legged herd animals found in the Naboo swamps. Commonly trained by the Gungans to serve as battle mounts, they were sure-footed and capable of great bursts of speed.

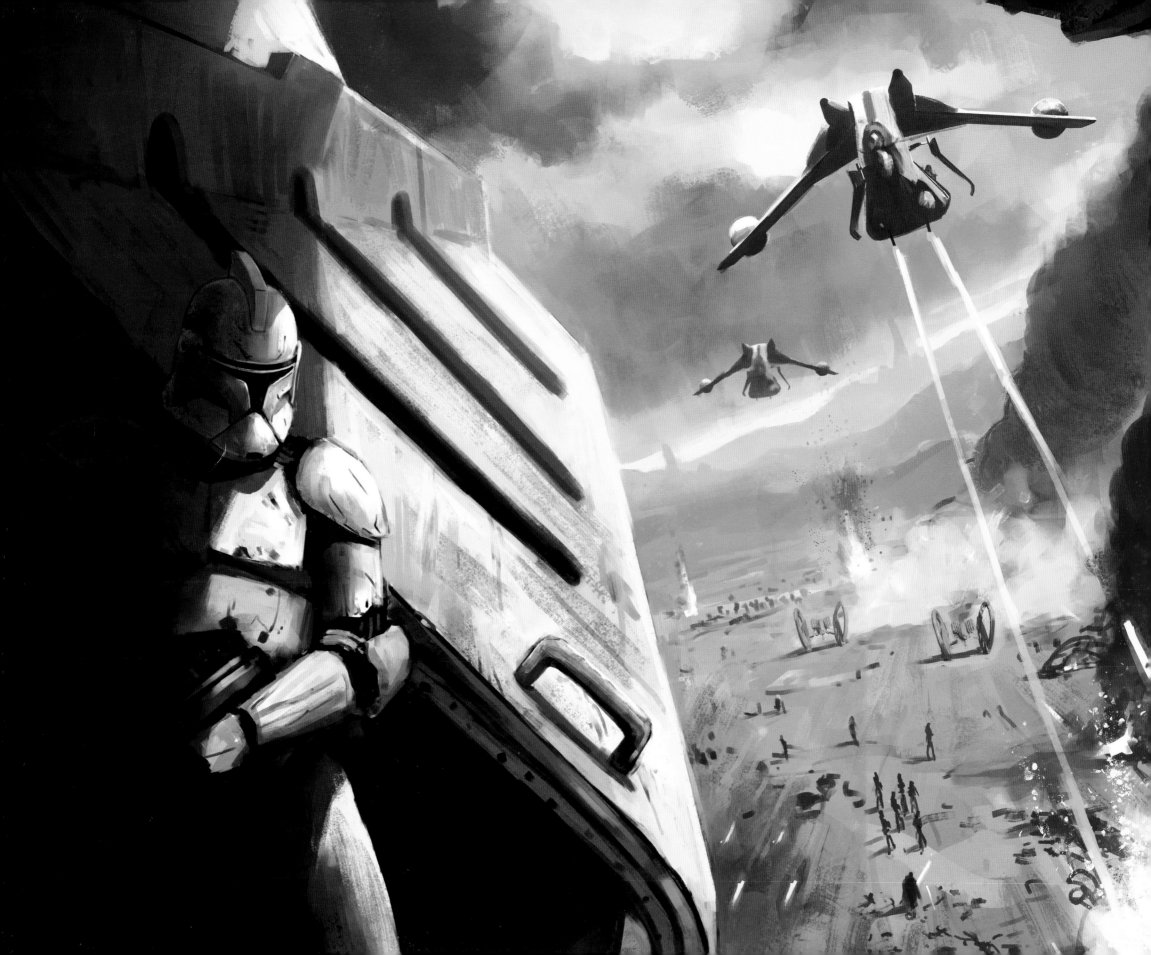

BATTLE OF GEONOSIS

- GROUND -

When Jedi Master Dooku left the Order, he returned to his homeworld to take up the aristocratic luxuries owed to him as a hereditary count. No one expected him to emerge as the head of a nascent political revolution.

A gifted orator, Dooku swayed the crowds that gathered beneath the royal balcony on Serenno. The newsnets broadcast his speeches to eager listeners throughout the galaxy. By fanning the flames of corporate resentment toward the Republic following the Trade Federation's defeat at Naboo, Count Dooku attracted clandestine support from the galaxy's commercial powers. The allegiance of thousands of Republic worlds followed, each of them eager to ally with Dooku's splinter government.

The movement called itself the Confederacy of Independent Systems. Its members became known as Separatists. Faced with a looming civil war, Supreme Chancellor Palpatine responded to the crisis with empty negotiations that went nowhere.

But both Palpatine and Dooku knew exactly what they were doing. In their roles as Darth Sidious and Darth Tyranus, they had orchestrated a political situation that would inevitably tip into war. Its flashpoint would be the desert world of Geonosis.

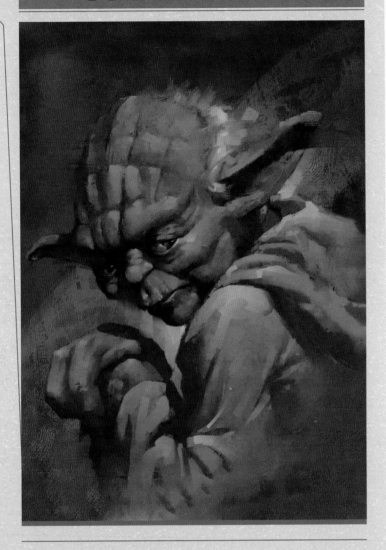

MASTER YODA

Unaccustomed to military command despite living many centuries, Jedi Master Yoda led the Republic clone troopers at Geonosis in their first-ever battlefield action.

PRELUDE TO BATTLE

In pursuit of a bounty hunter, Obi-Wan Kenobi arrived on Kamino and found a clone army—200,000 strong, with many more on the way—which stood ready for immediate action, but whose origins remained murky. The Jedi Council soon learned of Kenobi's findings as well as another critical discovery.

During Kenobi's continued pursuit of the bounty hunter to the planet Geonosis, he found a battle droid factory churning out the same droids that had been used by the Trade Federation to invade Naboo. Eavesdropping on a discussion between Dooku and the galaxy's commercial powers, Kenobi confirmed that the Trade Federation, Techno Union, Commerce Guild, and other megaconglomerates stood ready to throw their financial resources behind armed secession from the Republic.

The Jedi lacked the strength to stand against Dooku's Separatists on their own. The clone army Kenobi had discovered, who had been conditioned to receive Jedi orders, would fill a gaping hole in the Republic's defense.

Master Yoda traveled to Kamino to claim the clone army. Master Mace Windu assembled a force of two hundred Jedi for a surprise strike on Geonosis with the hope of forcing Dooku's surrender.

Master Kenobi, meanwhile, had fallen into Separatist custody. Jedi Anakin Skywalker and Senator Padmé Amidala came to his aid but became prisoners themselves. Each of the three received a sentence of death on the grounds of treason against the Confederacy of Independent Systems. Their execution— using the ancient Geonosian style of petranaki, in which condemned prisoners were fed to wild beasts—would occur immediately. Master Windu's mission to Geonosis now had a deadline.

TACTICAL ANALYSIS

Count Dooku, Geonosian leader Poggle the Lesser, and Trade Federation viceroy Nute Gunray took their seats in the arena to witness the deaths of Kenobi, Skywalker, and Amidala. To the amusement of the crowd, the condemned prisoners kept themselves alive for a time. Amidala struggled to keep out of range of a lithe nexu and its claws. Kenobi avoided the skewering stabs of a hard-shelled acklay. Skywalker used the Force to lull a charging reek and win its obedience. Yet these efforts only delayed what would have been their inevitable executions had Mace Windu not arrived.

> ## "BUT DOOKU WOULD NEITHER APOLOGIZE NOR SURRENDER."

Windu's Jedi arrived all at once, storming the arena with their lightsabers drawn. But Dooku would neither apologize nor surrender. His battle droids attacked, and the arena was suddenly filled with blaster fire, lightsaber swings, and the destructive ripples of sonic cannons.

Dooku's droids gained the upper hand, just in time for Master Yoda to arrive with a fleet of *Acclamator*-class assault ships. A clone-crewed gunship brought Yoda to the floor of the arena, where he fought to defend the surviving Jedi.

The arena could not contain the fighting, so the conflict spilled out onto the adjacent desert plain. Not knowing what opposition they might face, the Republic offloaded nearly everything it had brought from Kamino: clone troopers, AT-TE walkers, SPHA-T heavy artillery cannons, and air support in the form of LAAT gunships. The clones awaited their orders, preparing for a counterattack that wasn't long in coming.

Fresh from the assembly line, Separatist battle droids and heavier super battle droids marched on the Republic's

position. Tank-like spider droids brought up the rear, while fast-moving Hailfire droids buzzed the perimeter and primed their antivehicle missiles.

Poggle the Lesser directed his forces from a secure command bunker. He only sought to delay the Republic long enough for his Separatist clients to take delivery of their stock and carry it offworld. Any battle droids not already marching toward the enemy were directed aboard the Trade Federation's core ships and the Techno Union's Hardcell transports.

The Geonosians had other assets to protect, including the schematics for a new class of superweapon. Count Dooku had ordered the Geonosian engineers to develop the weapon's hyper-matter-fueled superlaser, but with the planet's security now compromised, Dooku seized all research completed to date. The Geonosian weapon would later take shape as the Death Star.

The Republic had a numerical advantage over its opponent, but its equipment had never been tested under fire, and the army's command structure remained unclear. The clone troopers automatically deferred to any Jedi, and some Jedi Knights took clone platoons onto the battlefield to engage in direct combat with droid troops. The resulting risk of friendly fire forced many AT-TEs to disengage, leaving them vulnerable to missile strikes from Separatist Hailfires.

The Separatists, however, had negligible air support. With the skies theirs to command, the Republic used gunships to scout the battlefield and to cut down knots of battle droids with antipersonnel lasers. A few nee-dle-nosed Geonosian starfighters took to the air, but with their small numbers they easily fell prey to the mo-tion-tracking rockets fired by vigilant LAATs.

When the gunships finally took out the last Hailfire, the Republic pressed forward to the site of the Separatist evacuation. Fully loaded cargo transports launched into orbit as the Republic scrambled to set up its SPHA-T cannons. The untested SPHA-Ts needed careful placements and extended targeting times, but neither requirement could be indulged in the face of a mass escape. Firing in sync, the heavy cannons took down a Trade Federation core ship and several other transports.

But the vast majority of Separatist vessels—carrying the members of the Separatist Council—had already departed by the time the Republic claimed the field.

> "POGGLE THE LESSER ONLY SOUGHT TO DELAY THE REPUBLIC LONG ENOUGH FOR HIS SEPARATIST CLIENTS TO TAKE DELIVERY OF THEIR STOCK AND CARRY IT OFFWORLD."

AFTERMATH

By capturing Geonosis, the Republic temporarily halted the production of battle droids. But most of the war matériel that bore the Geonosian stamp had already vanished into hyperspace. Furthermore, the Separatist Council had escaped.

The Republic found that its new planet held little strategic value once the engineers announced they could not reconfigure the Geonosian factories for Republic needs. In fact, the Republic assigned so few resources to the occupation that the Separatists retook the world in less than a year.

Public perception became the most important legacy of the Battle of Geonosis. When word of the conflict hit the newsnets, no citizen of the Republic or the Confederacy could deny the truth. The galaxy was at war.

ARCHDUKE POGGLE THE LESSER

As the leader of the dominant Stalgasin hive, Poggle the Lesser seemingly controlled everything on Geonosis, including its combat forces. Because the Separatist droid soldiers had been made in his factories, he understood their capabilities better than Dooku.

COMBATANTS

1 JEDI KNIGHTS: Although structured as a peacekeeping force, the Jedi Order was pressed into frontline combat on Geonosis. Jedi lightsabers had both offensive and defensive uses, and Force abilities such as focused telekinesis were effective against smaller targets.

2 CLONE TROOPERS: The Republic's clone troopers were genetically identical soldiers grown from the template of bounty hunter Jango Fett. All of the clone troopers at Geonosis had been artificially accelerated to adulthood in less than ten years.

3 SUPER BATTLE DROIDS: A taller, stronger, better-armored version of the B1 battle droid, Baktoid's B2 super battle droid could withstand multiple close-range hits and featured a double blaster cannon built directly into its forearm.

4 GEONOSIAN WARRIORS: The Geonosians were an insectoid, hive-based species with an entire caste devoted to warfare. Members of the warrior caste could fly and were protected from injury by tough exoskeletons.

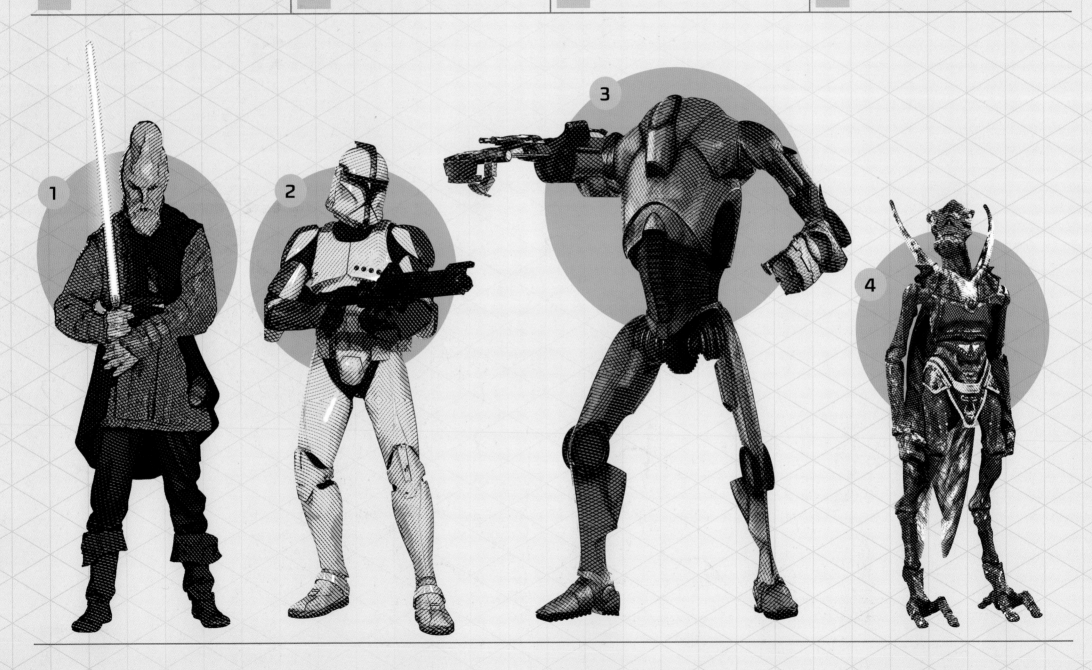

Jedi Knight Bultar Swan

GEONOSIS

The battle wasn't supposed to happen. I knew it *might* happen, but when you're a Jedi, you get accustomed to surrenders as soon as you ignite your lightsaber. And in my defense, we had more than two hundred lightsabers packed into that arena, with Master Windu's only a centimeter from Dooku's throat.

They *should* have surrendered, but instead they fought back. Suddenly all the relatively new Knights like me, who mistook our overconfidence for foresight, had to figure out what to do next.

I let my saber training take over. Muscles moved by themselves as I unconsciously ran the sweeping and batting exercise that is blaster deflection. My brain, however, was racing at lightspeed. Events moved alarmingly fast, and they weren't moving in our favor. My focus narrowed to myself and my moment-to-moment survival. After I cut down a super battle droid, I looked beyond it and saw Master Yoda standing inside a gunship. All I could think was, *How long has he been here?*

Stass Allie and I spent most of the battle fighting back to back. We leapt onto the deck of a hovering gunship and held on tight as it shot upwards. Its repulsorlifts whined as it cleared the arena walls and made a fast landing on the desert plain outside.

What I saw was bigger than anything I had imagined. Distant rectangles bobbed up and down as they marched in our direction, each speck in the formation representing an armed battle droid. Hoop-wheeled tanks roared past the droids, stirring up clouds of red dust. Behind us, the Republic kept dropping machines that I didn't recognize, like walking tanks and heavy cannons. And everywhere I saw soldiers in white armor.

So this was what war looked like. Stass and I shared a nod, raised our lightsabers, and charged.

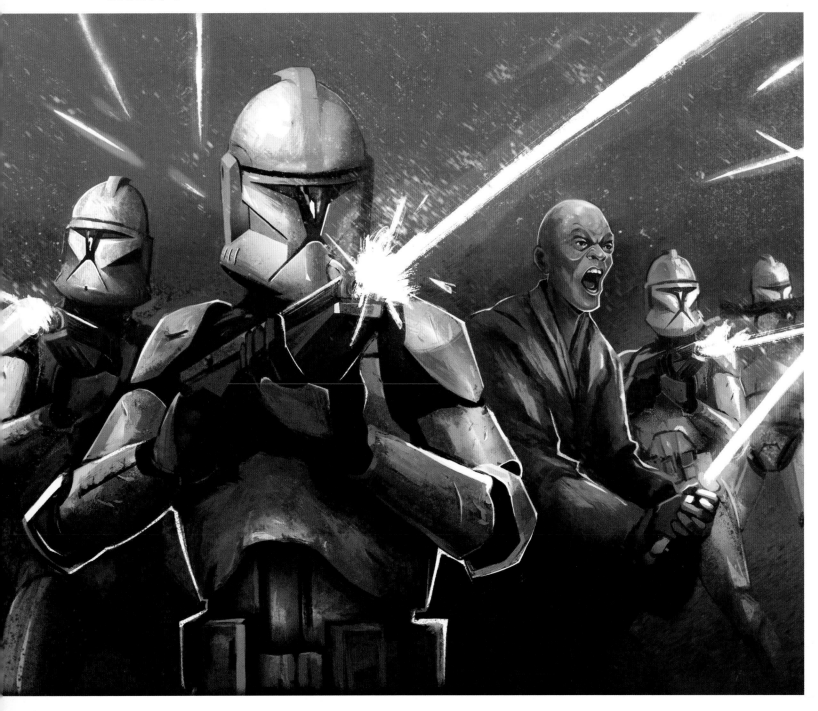

TOOLS OF WAR

1 LAAT GUNSHIP: The Republic gunship, or Low Altitude Assault Transport, was used in a variety of mission configurations at Geonosis, including troop transport, fire support, and cargo transport. Each LAAT bristled with weapons such as laser turrets and missile launchers.

2 AT-TE: The six-legged All Terrain Tactical Enforcer was a heavy walker used for transporting clone troopers and assaulting fortified positions. It was armed with six antipersonnel laser cannons and a huge mass-driver cannon mounted on its back.

3 SPHA-T: As the heaviest hitter in the Republic's ground arsenal, the Self-Propelled Heavy Artillery Turbolaser fired a composite turbolaser beam able to punch through thick ship hulls. Its twelve legs enabled it to move carefully across uneven terrain.

4 HAILFIRE DROID: The Separatists deployed the IG-227 Hailfire droid tank as a mobile missile platform to target Republic vehicles. Large wheels enabled it to travel at high speeds, and its dual missile racks were packed with thirty heat-seeking rockets.

5 SPIDER DROID: The Separatist spider droids came in both heavy tank varieties (the OG-9 homing spider droid) and antipersonnel varieties (the DSD1 dwarf spider droid). Both were employed by the Commerce Guild for use against its enemies, which included delinquent creditors prior to the Battle of Geonosis.

6 GEONOSIAN SONIC CANNON: The LR1K sonic cannon was an artillery emplacement that fired a rippling sonic blast. Manufactured by the Gordarl Weaponsmiths on Geonosis, the sonic cannon required a crew of two to aim and fire.

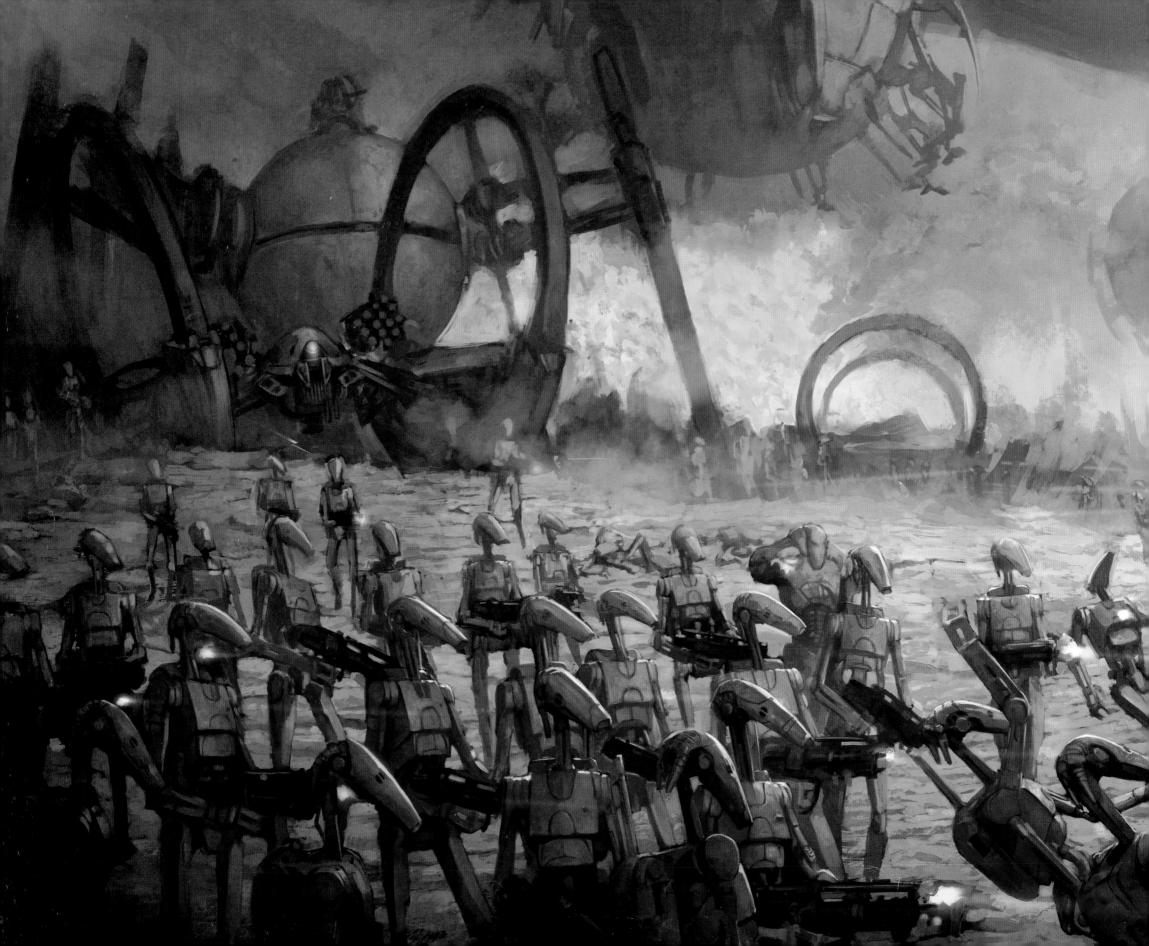

BATTLE OF GEONOSIS

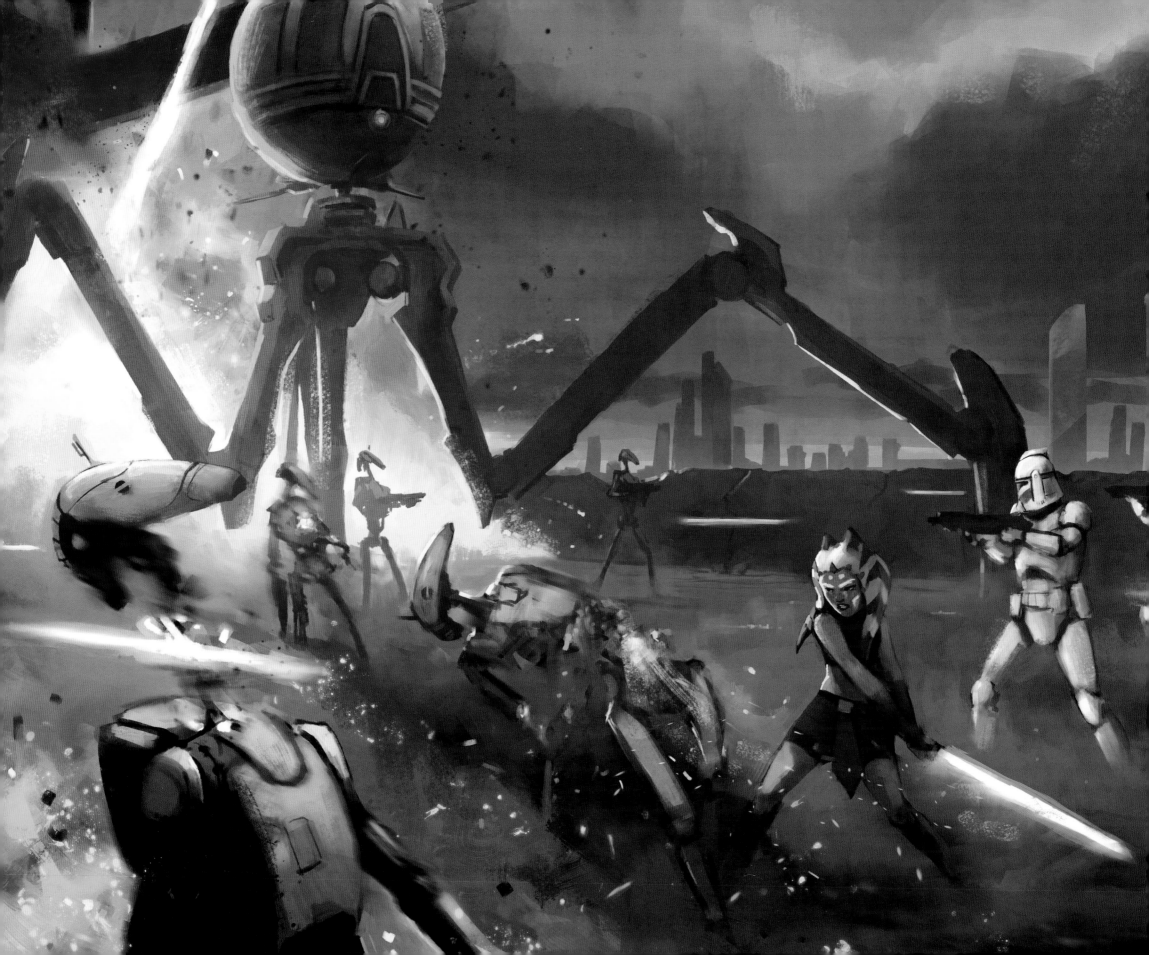

BATTLE OF CHRISTOPHSIS

- GROUND -

The Clone Wars spread everywhere from the Colonies to the Outer Rim. As the Separatists rushed to claim new holdings, the Republic leapt from battle to battle in a frantic effort to stanch its territorial losses. The Jedi Order had assumed military command over the clone trooper army, but very few Jedi were accustomed to fighting—and neither were the soldiers they commanded. Until Geonosis, the clone troopers' only experience with warfare came from their innate genetic programming and the simulation training they had run on Kamino.

At Christophsis, the Separatists made a bold move. A naval blockade and a brutal ground campaign claimed the planet and indicated that the Separatists were in it for the long haul. Despite the odds, the Republic had no choice but to take action once word got out that the Separatists had targeted a peaceful Senate relief mission for extermination.

The Battle of Christophsis became a live-fire test for new tactics. It set the template for subsequent Clone Wars conflicts, with blockade running and clone/Jedi teamwork proving vital to future Republic success.

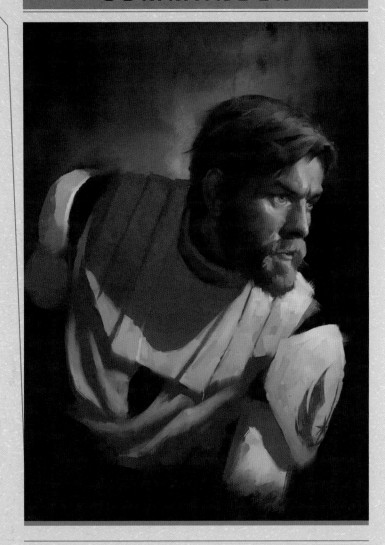

GENERAL OBI-WAN KENOBI

The Jedi commander at Christophsis had little command experience prior to the battle. He hoped to end the hostilities with minimal bloodshed.

PRELUDE TO BATTLE

Christophsis fell to the Separatists not long after the Battle of Geonosis. By possessing the Outer Rim world, the Separatists gained a port on the Corellian Run and a planetary crust that bristled with mineral wealth.

Anticipating a Republic counterattack, the Separatists brought in a thirty-ship armada under the command of Admiral Trench and erected a naval blockade. On the planet's surface, droid armies under General Whorm Loathsom wiped out pockets of resistance. Loathsom's list of "hostile targets" included a newly arrived, Senate-sponsored relief mission led by Bail Organa of Alderaan.

The Republic hoped to break the blockade not with force, but with trickery. Their experimental stealth ship could hide from sensors with its cloak-powered invisibility screen, but Admiral Trench deployed countermeasures that revealed the ship's position. A tense game of hide-and-seek ended with Trench's homing torpedoes looping around on the ship that had fired them, destroying its bridge.

The Separatist blockade faltered following Trench's defeat, and the Republic landed a company of clone troopers in the capital city of Chaleydonia and rid the planet of any ground forces.

TACTICAL ANALYSIS

After landing their troops in Chaleydonia, Jedi commanders Obi-Wan Kenobi and Anakin Skywalker captured the city's western district and its town square. They encountered little resistance. Loathsom's troops had largely abandoned Chaleydonia for the eastern exurbs, seeking to annihilate Senator Organa's volunteers and any surviving Christophsian rebels. Alerted to the Republic's incursion, Loathsom returned to Chaleydonia with all possible haste, and the battle devolved into a stalemate.

Immediately upon arrival, the Republic faced an intelligence crisis. One of its own clone troopers, a first-batch Kaminoan product bearing the rank of sergeant, had witnessed the chaos of the Battle of Geonosis and concluded that the Jedi were not competent commanders. On his own initiative, he leaked Republic troop movements to Asajj Ventress, a Force-strong Separatist commander and one of Count Dooku's closest agents.

Convinced that the defeat of the Jedi would bring an early end to the war and thus free his fellow clones from indentured servitude, the traitor betrayed Kenobi's and Skywalker's positions to Ventress. Both Jedi escaped the ambush, and analysis of a droid's memory banks proved that the Separatist attackers had acted on insider information.

> "THE ARRIVAL OF A REPUBLIC TRANSPORT GAVE KENOBI HOPE, BUT IT DID NOT CARRY THE REINFORCEMENTS HE HAD REQUESTED."

The Jedi commanders undertook a top-to-bottom sweep of their headquarters to find the leak and eventually uncovered the clone sergeant's duplicity. Before they could place him into custody, the traitor set off an explosion that annihilated the Republic's gunships and AT-TEs.

Because the Republic had lost its heavy walkers through sabotage, the commanders chose to fortify their position in Chaleydonia with long-range AV-7 artillery cannons. After requesting reinforcements from the Republic, General Kenobi and his troops hunkered down and waited.

Their cannons kept the battle droids at bay, but it wouldn't be long before Loathsom overran the Republic's

fortification with sheer numbers. Skywalker and a squad of jet-pack troopers thinned the enemy's numbers. By concealing themselves in the upper stories of the buildings along the central thoroughfare, Skywalker's squad could hit the middle of the battle droid formations and cause maximum damage before withdrawing. In a single skirmish, Skywalker took down three enormous tri-droids.

Stung by his losses, Loathsom pulled his forces back to the Separatist-controlled section of Chaleydonia. The arrival of a Republic transport gave Kenobi hope, but it did not carry the reinforcements he had requested. Its lone passenger—Jedi Padawan Ahsoka Tano—paired up with Skywalker. Kenobi put in a second request for aid.

Loathsom attacked again, but this time a mobile energy shield protected his battle droids from Republic artillery. The shield advanced at the same pace as the droids, whose lines had been bolstered with the addition of NR-N99 tank droids and AATs. With the Republic's cannons rendered useless, it wouldn't take long before the droids reached the clones' front lines.

Skywalker and Tano set out to sabotage the enemy's shield. Concealing themselves, they waited until the droid formations passed them. They then emerged from cover to assault the generator and its complement of barrel-headed LR-57 combat droids.

Meanwhile, General Kenobi requested a parley with General Loathsom to negotiate the terms of the Republic's surrender. His offer was false, meant only to buy time. Although Loathsom had his suspicions, Kenobi's action delayed the Separatists' final push long enough for Skywalker and Tano to destroy the generator.

With the shield gone, the Republic opened fire once again with its long-range artillery. The cannons demolished Loathsom's front line and snarled the boulevard with wreckage. Kenobi seized Loathsom as a prisoner of war.

The Republic reinforcements arrived in orbit, too late to help secure the ground victory but just in time to discourage the Separatists from pushing any farther. The Separatist blockade broke up and vanished into hyperspace.

AFTERMATH

Republic High Command used the victory at Christophsis as an example of what Jedi and clone troopers could do when they worked together and weren't held back by the inefficiencies that had caused issues at Geonosis.

The facts were clear: a single Jedi and an armed squad of troopers could carve through an entire column of battle droids. The Separatists saw the same data and came to a disturbing conclusion. They began to research "Jedi-proof" biological weapons, some of which—the defoliator and the Blue Shadow virus in particular—would soon see deployment.

The Republic covered up all evidence of the clone traitor who set back its early efforts on Christophsis. In particular, the motivations behind the betrayal remained classified to everyone except Republic High Command. The alarming possibility that the Kaminoan clones might not be 100-percent obedient was minimized to prevent similar sentiment from spreading in the ranks. The Jedi, who had viewed commanding living beings as somehow more noble than the Separatists' reliance on machines, now had to deal with the complicating factor of free will.

General Kenobi's false surrender at Christophsis was a boon to the Separatist-controlled media, who viewed the incident as clear evidence of the Republic's duplicity. Almost no conditional surrenders were offered by either side for the remainder of the war.

GENERAL WHORM LOATHSOM

With a long history of military service to the planetary defense forces of Kerkoidia, Loathsom earned a post as a Separatist general, commanding droids that formerly served the minor corporate body known as the Retail Caucus.

COMBATANTS

1 **JEDI KNIGHTS:** After Geonosis, the Jedi Order structured itself into military ranks, including general and commander. The Jedi Knights continued to serve on the front lines and took on a leadership role in the tactical deployment of Republic clone troopers.

2 **CLONE TROOPERS:** With several skirmishes under their belts, the Republic's clone troopers applied their combat experience to gain an early advantage over their robotic Separatist enemies. As they gained a better understanding of the combat capabilities of their Jedi commanders, clone troopers learned when to step forward and when to hold back.

3 **BATTLE DROIDS:** B1 battle droids continued to be produced in great numbers throughout the Clone Wars, now without the shortsighted reliance on a central command signal that had doomed the Trade Federation at Naboo. Cheap manufacturing costs often allowed the Separatists to overwhelm their enemies with battalion after battalion of battle droids.

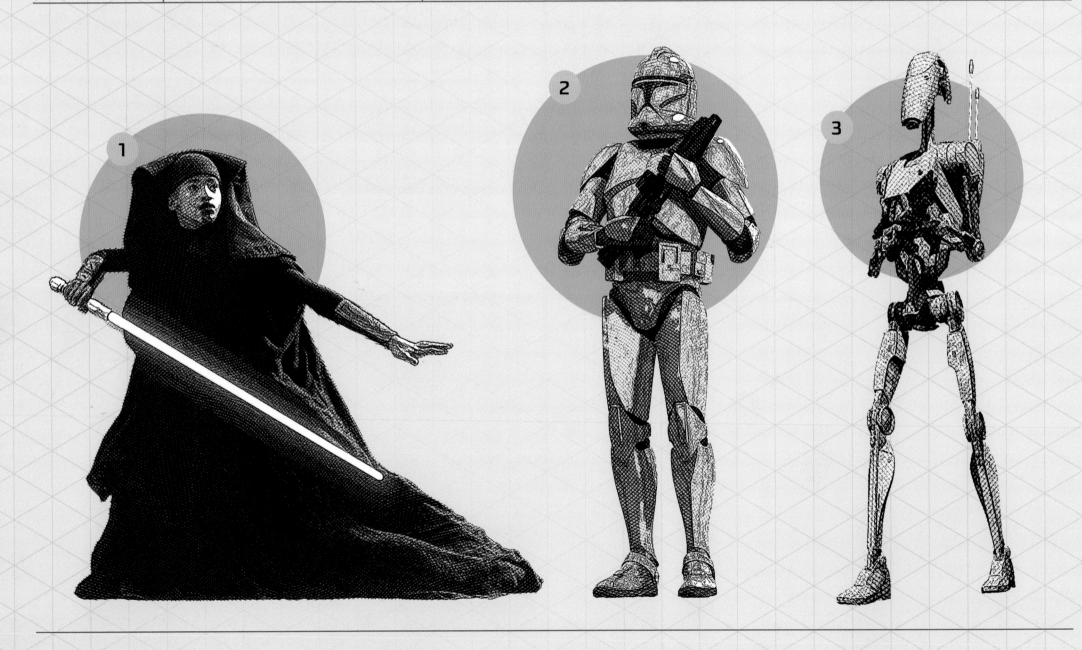

COMBATANTS

4 **SUPER BATTLE DROIDS:** Because a B2 super battle droid could better stand up to a Jedi, the Separatists began producing greater numbers of this model early in the Clone Wars. Despite their combat advantage, super battle droids were often outnumbered by B1 battle droids by a factor of one hundred to one.

5 **LR-57 COMBAT DROID:** Top-heavy, cylindrical-headed automatons manufactured by the Separatist Retail Caucus, LR-57 combat droids moved on two legs and attacked with double-blaster cannons at the end of each arm. Scarce in number, LR-57 droids primarily saw use as bodyguards or sentinels.

Jedi Padawan Ahsoka Tano

Jedi Knights are supposed to choose their Padawan apprentices, but the Jedi Council started bending rules following the outbreak of war. Ahsoka Tano arrived on Christophsis with orders from the Council to study under Anakin Skywalker as his apprentice. Skywalker, blindsided by the appointment and reluctant to compromise his fighting style, briefly considered defying a direct order from the Council.

Tano had been with the Jedi Order since the age of three, after Jedi Master Plo Koon found her. Confident and eager, she was judged to be a fit with Skywalker in light of his similar qualities. The Council saw promise in the partnership and dropped Tano into the thick of the Christophsis ground campaign.

Though taken aback by the possibility of a master unwilling to train her, Tano quickly established a rapport with Captain Rex, Commander Cody, and the rest of the Republic's clone troopers she encountered. They respected her for achieving a Jedi's rank, and they provided valuable intel on the composition of the Christophsis opposition.

When Skywalker finally suggested a team-up to sabotage the Separatist shield generator, Tano added her lightsaber to his. After taking out the heavy combat droids, she blew the target sky-high.

Her first partnership with Skywalker a success, Ahsoka Tano settled in for what would prove to be a very long war.

Senator Bail Organa

CHRISTOPHSIS

The Separatists starved Christophsis. It was one of the more despicable tactics they had introduced, but then again, it was still early in the war. There was plenty of vileness yet to come.

Any cargo ship that brought supplies to Christophsis ran into warships with turbolasers and an order to turn around and go back to where they came from. Our Senate relief team managed to slip food and medicine down to the surface, but Admiral Trench patched up the blockade nice and tight. We were trapped.

I knew the Republic would come, but we had to hold out against the Separatists until they did. General Loathsom moved against us as if he was desperate to wipe out a black mark on his ledger. The Confederacy's political narrative had become so twisted that killing the volunteers of a Senate mercy mission would probably have resulted in a medal instead of a prison sentence.

We stayed holed up in the cellar beneath the Minister of Sustenance's compound. Our ears rang from the booms of Loathsom's heavy cannons. When our own guns went silent, I readied myself for the end, but when I looked at the scanner I saw Loathsom's troops in full retreat.

The Republic had landed in the capital city. The real battle for Christophsis was about to begin.

TOOLS OF WAR

1 **AV-7 ANTIVEHICLE CANNON:** This self-propelled artillery unit, manufactured by Taim & Bak and used by Republic forces, could fire long-range plasma shells in parabolic arcs. The AV-7 traveled on antigravity repulsorlifts, but when it reached firing range it would anchor itself to the surface with four stable legs.

2 **NR-N99 PERSUADER TANK DROID:** The Separatist Persuader used a central drive tread for locomotion, augmented by outrigger wheels on both sides for added stability. The Commerce Guild largely funded the manufacture of NR-N99 Persuaders, impressed by armament that included heavy repeating blasters, ion cannons, and concussion missile launchers.

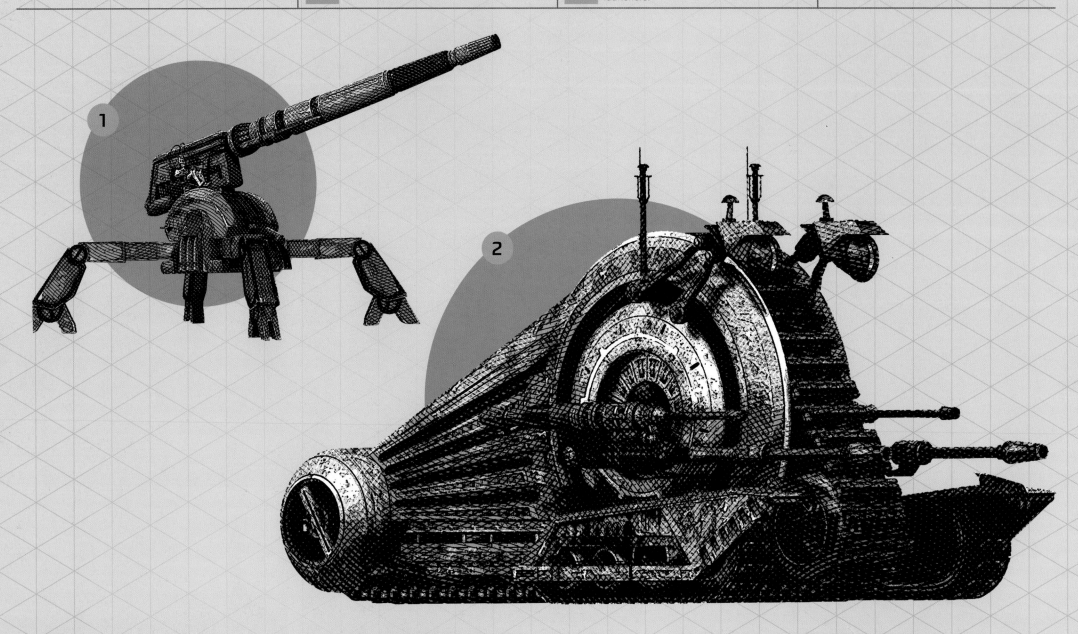

TOOLS OF WAR

3 **AAT:** After the Battle of Naboo, the Armored Assault Tank became a mainstay of the Separatist droid army during the Clone Wars. Often, battlefield generals used well-armored AATs as command vehicles.

4 **OCTUPTARRA TRI-DROID:** Primarily manufactured by the Techno Union division of the Separatist army, the Octuptarra was nicknamed the "virus droid" due to the biological plagues it sometimes carried. A typical Octuptarra was armed with three laser cannons placed equidistant around its central stalk.

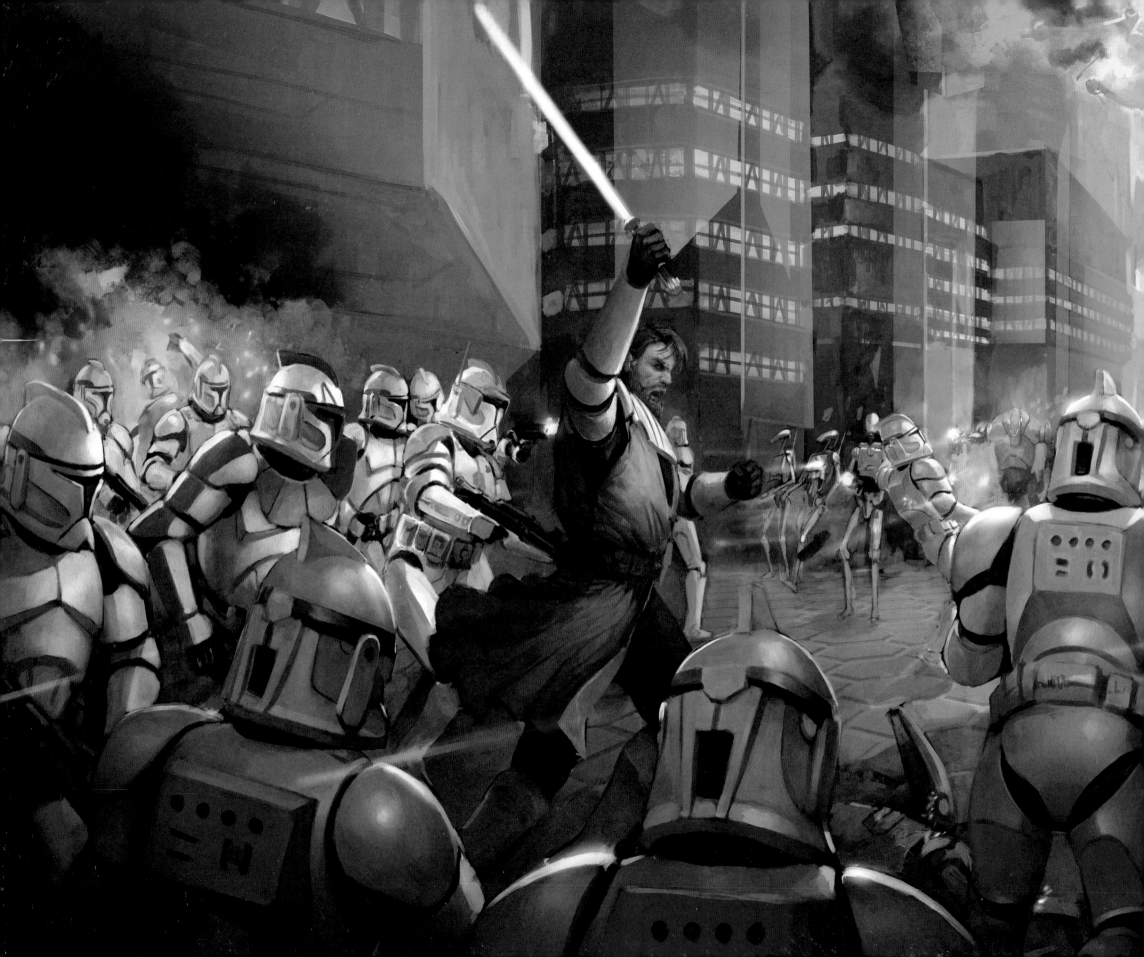

BATTLE OF CHRISTOPHSIS

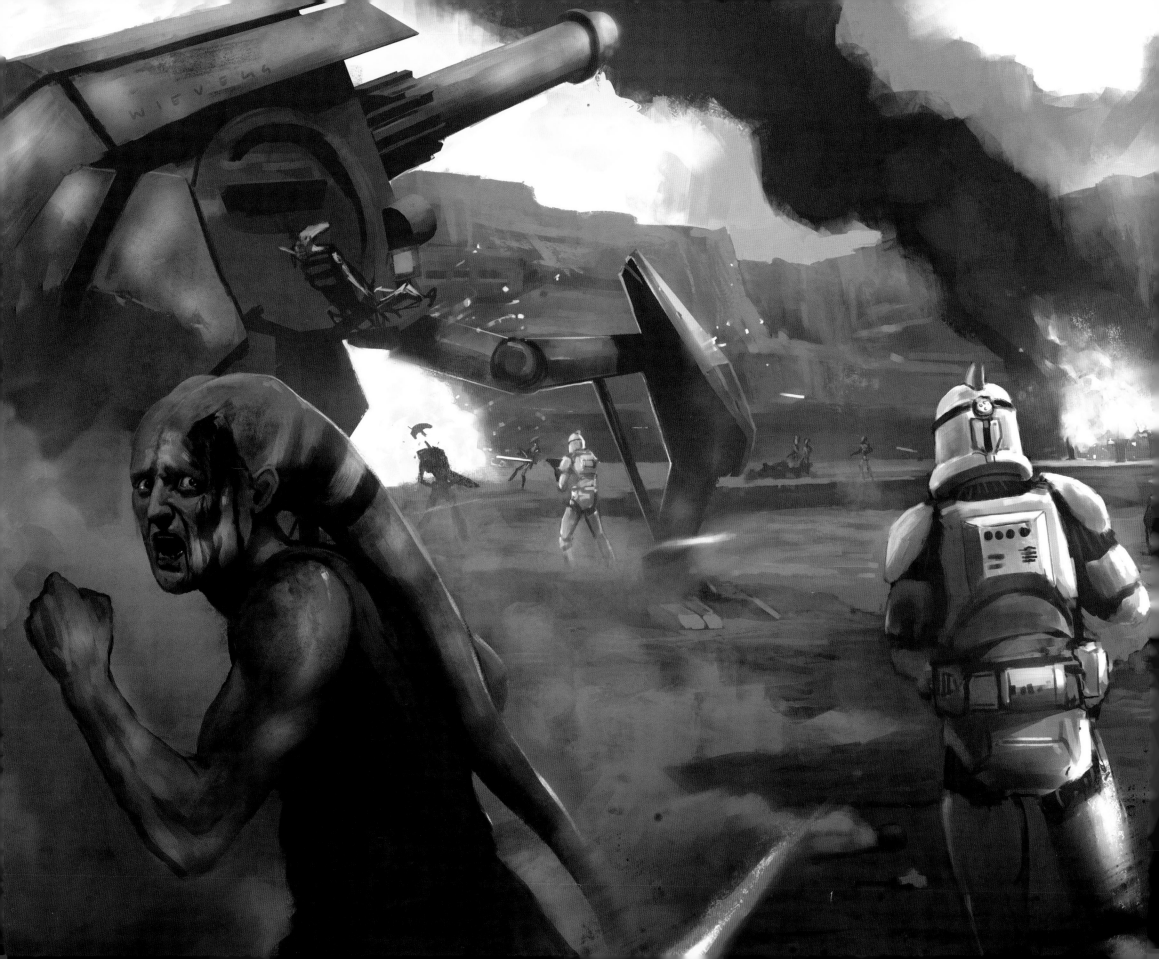

BATTLE OF RYLOTH
- GROUND -

Ryloth's hyperspace location made it a prize worthy to be claimed by the Republic and the Separatists. The cold facts seemed obvious to both sides, but the inhabitants of Ryloth viewed their intentions with contempt. Ryloth became the first of many worlds on which native populations made it clear that they did not want to ally with either side, but simply wanted to be left alone.

In the years leading up to the Clone Wars, thousands of planets had announced their membership in Count Dooku's Confederacy of Independent Systems. Thousands more reaffirmed their loyalty to the Republic and its supreme chancellor. The outbreak of war only polarized the factions further. For worlds like Ryloth—officially a Republic possession—the struggle over separatism only underscored the ambivalence of its citizens.

The galactic government had never paid attention to local concerns. If the Republic now seemed to care about Ryloth, it was only because the planet offered a strategic staging point for missions across the Outer Rim.

For both the Republic and the Separatists, winning the territory would not prove to be the same thing as winning the hearts and minds of its inhabitants.

COMMANDER

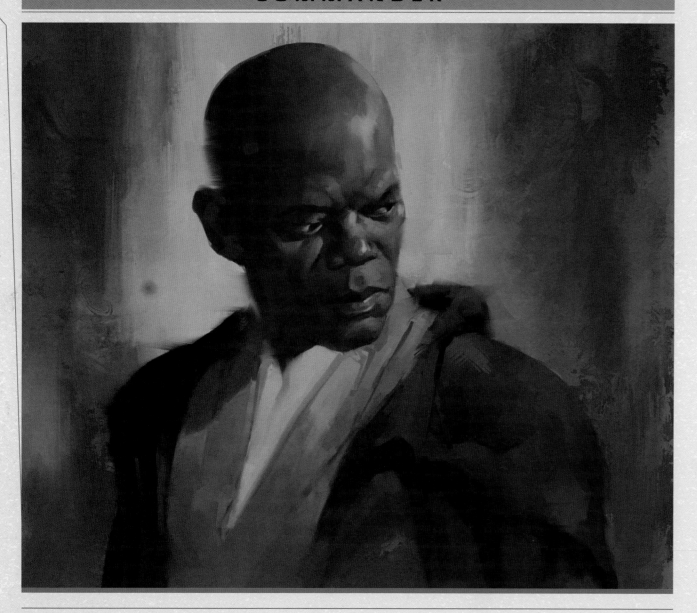

MASTER MACE WINDU

After Geonosis, Master Windu commanded countless battlefronts as the Clone Wars took hold. On Ryloth, Windu saw an opportunity to bring the local rebels over to his side.

PRELUDE TO BATTLE

Techno Union foreman Wat Tambor masterminded the Separatist invasion of Ryloth. Tambor struck fast, and soon a Republic garrison stood as the last remaining holdout. Local resistance leader Cham Syndulla and his homegrown forces fought the Separatists, but Tambor completed his annihilation of the garrison and claimed domination over all of Ryloth.

The triumphant Separatists settled into occupying the planet. Its troops fanned across the countryside to loot villages and bring their riches back to Tambor's fortress near the capital city of Lessu. Syndulla's fighters disappeared into the desert, harassing the Separatists with guerrilla tactics.

Republic forces arrived in the system to recapture Ryloth. Their first objective: take out a nest of proton cannons in the village of Nabat in order to permit future troop landings. Their second objective: seize Tambor's citadel, located atop a mesa and surrounded by a plunging chasm on all sides that acted as a natural moat.

The Republic did not have a huge invasion force, nor did it have air support. Ghost Company and General Obi-Wan Kenobi would handle Nabat, while Lightning Squadron and General Mace Windu made their plans to hit the fortress near Lessu.

TACTICAL ANALYSIS

Three Republic craft descended on Nabat, weathering a barrage of flak fired from the proton guns. Ghost Company disembarked under fire and vanished into cover. General Kenobi insisted on comm silence, for it was to be a stealth mission. Expecting the streets of Nabat to be crowded with Twi'lek citizens, Kenobi also ordered his unit to stow their rockets and detonators to minimize any risk to civilians.

But Nabat stood eerily empty. The Republic soon learned that battle droids had already rounded up every inhabitant and forcibly relocated them to the town square. The civilians had been seated around the base of each plasma cannon, limiting Ghost Company's options even further.

Two of Ghost Company's clone troopers, sweeping buildings in Nabat for enemies or traps, encountered a free Twi'lek. The girl had escaped notice inside an underground warren, its tunnels offering a clandestine path. Making their way through the tunnels, the Republic troops were able to slip past the droid sentries and reach Nabat's central plaza.

After fighting off a herd of ravenous gutkurrs, Kenobi and the clone troopers made their way to the plasma cannons. As soon as the Twi'leks being held spotted the Republic troopers, they turned on their droid captors. Ghost Company succeeded in neutralizing the Separatists' heavy guns.

Kenobi's care in minimizing civilian harm during his attack on Nabat paid diplomatic dividends. The Nabat elders, after helping to destroy the Separatists' heavy cannons, resupplied Ghost Company and provided intel on nearby droid fortifications. Although it is not known whether the news of the Republic's thoughtfulness reached the guerrilla forces of Cham Syndulla, in a small way General Kenobi had already started chipping away at Ryloth's cultural cynicism.

There *was* a difference between the Republic and the Separatists. Good-hearted intentions—while far from foolproof—were testaments to the sincerity of the Republic and the Jedi Order.

One mission had succeeded, but Jedi Master Mace Windu still needed to capture the fortress. He led his unit to

Battle of Ryloth
COMMANDER

EMIR WAT TAMBOR

Techno Union foreman Wat Tambor wore a full-body armored pressure suit as he conquered new worlds for the Confederacy. On Ryloth, the greedy Tambor hoped to seize many artifacts for his personal vaults.

GENERAL CHAM SYNDULLA

Freedom fighter Cham Syndulla attracted the loyalty of his people in a way that their Republic representative, Senator Orn Free Taa, did not. Revered for his integrity, Syndulla sought independence for Ryloth.

the outskirts of Lessu, where Separatist AATs killed dozens of clone troopers and decimated Windu's unit, leaving it at less than half strength. But Windu had chosen Lightning Squadron for a reason, knowing that its AT-RT drivers could cover a lot of ground in a short amount of time. Windu suspected that a recon operation would lead Lightning Squadron to Cham Syndulla and his freedom fighters.

An ambush on a Separatist patrol brought Windu and Syndulla together. The Twi'lek revolutionary, who saw no benefit in a long-term Republic alliance, agreed to help Windu against Wat Tambor only to dislodge the greater of his two enemies. With Syndulla's guerrillas bolstering his weakened squad, Mace Windu advanced on Tambor's fortress.

The citadel could only be reached by way of an energy bridge, which remained deactivated when not in use. The clone troopers and Twi'leks concealed themselves until an automated convoy, its transports loaded with plunder, approached the chasm. Windu and two troopers concealed themselves inside one of the MTTs, and Tambor's droids extended the energy bridge for the convoy's passage.

The MTT made it halfway across the chasm before the Separatists discovered the deception and deactivated the bridge. As the MTT plunged into the depths, Mace Windu Force-shoved his troopers to safety on the far side. He saved his own skin by dropping onto a Separatist STAP flier.

The clone troopers who had been pushed across the chasm secured the control room and locked the bridge into position. The Republic's AT-RT drivers and Syndulla's blurrg-mounted cavalry led the charge. The citadel quickly fell, and Wat Tambor surrendered himself into Republic custody.

AFTERMATH

Ryloth remained in Republic hands, but the Battle of Ryloth became a propaganda tool for both sides. The Republic advertised Wat Tambor's use of living shields and his bombing raids against civilian targets, condemning what they called a "leave nothing but ashes" philosophy of hopelessness. The Separatist spin saw those same actions framed as necessary steps to root out a dangerous militia. Had the Republic not insisted on escalating the conflict, the Separatists claimed, such extreme actions would not have been needed.

The Republic's arguments may have looked more convincing, but the implication of the Separatists' story was chilling. Locals who took up arms to fight off their occupiers would lose everything.

> "THE REPUBLIC'S AT-RT DRIVERS AND SYNDULLA'S BLURRG-MOUNTED CAVALRY LED THE CHARGE."

On the other hand, Mace Windu's alliance with Cham Syndulla, as well as Ghost Company's collaboration with the people of Nabat, demonstrated that the Republic could successfully operate alongside planetary resistance forces while minimizing civilian casualties. Using Ryloth as a template, Republic High Command experimented by sending commando squads to Separatist-occupied planets to coordinate with local freedom fighters on missions of sabotage and harassment. The initiative found some success on Aridus, Tynna, and other worlds, but attracted criticism that the Republic was unfairly exposing civilians to punitive retaliation.

The battle cemented Cham Syndulla's reputation as a selfless crusader for Ryloth's independence. Years later, he would become a thorn in the Empire's side when his Free Ryloth insurgents harassed Imperial occupiers.

COMBATANTS

1 **CLONE TROOPERS:** By the time of the Battle of Ryloth, the Republic's clone troopers had gained a veteran's view of the battlefield and had begun to employ new tactics, including guerrilla strikes and collaboration with local resistance forces. Diplomacy, however, proved a difficult skill to master and remained a matter on which clones deferred to their Jedi commanders.

2 **LIGHTNING SQUADRON DRIVERS:** The clones of Lightning Squadron consisted of ARF Troopers specially trained to operate high-speed AT-RTs. Mostly called on for battlefield reconnaissance, Lightning Squadron proved equally adept at executing surprise strikes or skirmishes with Separatist advance forces.

3 **SUPER BATTLE DROIDS:** The B2 super battle droid became a more common combatant as the Clone Wars wore on, given that its armored chassis could withstand a blaster strike and its rapid-fire forearm blaster could overwhelm a unit of rookie clone troopers.

4 **TWI'LEK FREEDOM FIGHTERS:** Cham Syndulla led the local resistance on Ryloth, striking from cover and retreating before Separatist reinforcements could arrive. The Twi'lek fighters kept on the move, traveling rapidly on the backs of trained blurrg mounts.

TALES OF VALOR

Advanced Recon Force Trooper Razor

CT-6910, also known as Razor, served as an Advanced Recon Force trooper in Lightning Squadron in the Republic's 91st Reconnaissance Corps under the command of Adi Gallia. As a skilled AT-RT driver, he aided Jedi Master Mace Windu during the Ryloth campaign by helping to locate Cham Syndulla and his freedom fighters.

Razor, with his Lightning Squadron comrade Stak, volunteered to accompany Mace Windu during the infiltration of Emir Wat Tambor's fortress by stowing inside an enemy MTT to cross an energy bridge. When the ruse failed, he got his first hands-on experience with the Force after Master Windu levitated him over to the lip of the canyon.

As soon as his feet hit the ground, Razor stormed the compound and took out the battle droids guarding the control room. He fought off a commando droid that caught him in a stranglehold, and managed to power up the energy bridge so the rest of the Republic/Twi'lek fighters could cross the gap and complete the victory. For his actions on Ryloth, Razor received a commendation for valor.

I WAS THERE

Numa

RYLOTH

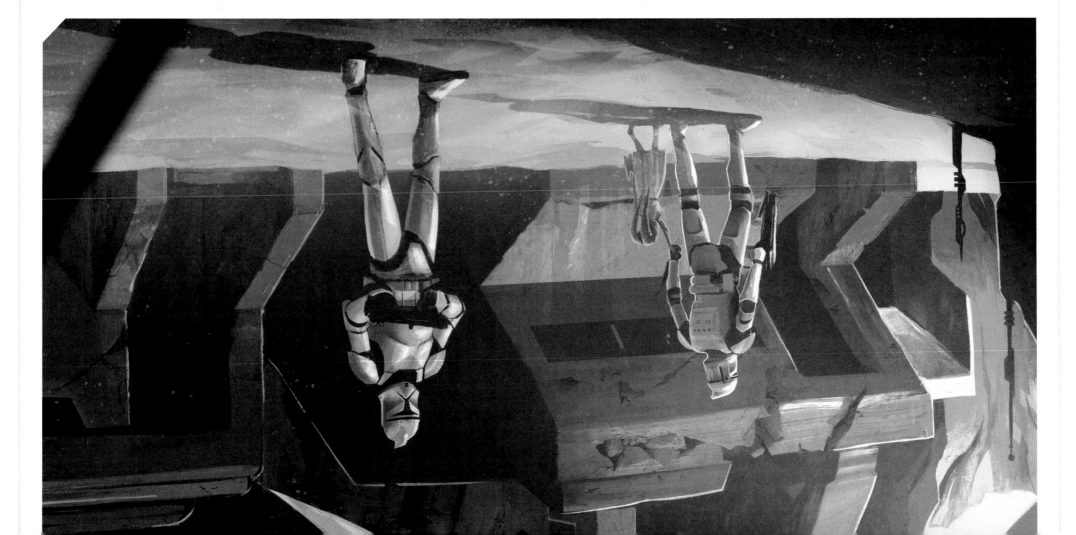

It happened a long time ago. It's hard for me to talk about, but it's not hard to recall. The thing I remember most is my tooka doll. I was only five. Can you blame me?

The droids rounded up my family and everybody else in Nabat. They moved them into the plaza around big guns that had never been there before. I was too young to understand that my mother and my father and my uncle had become living shields. But I knew that to reach the plaza I had to face the droid guards or pass through the gutkurr stables. I was too scared to do either, so instead I kept out of sight.

First, I ate all the food in my house. Next, I raided our neighbor's house, and after that, I took whatever I could

At that age I didn't know what clone troopers were or that they were on a different side than the droids. But once they took off their helmets, I noticed that they shared the same face. I called them *nerra*, for brother.

They fed me, and I felt safe. I felt like they could be my brothers too.

I soon met more of them. I met a Jedi too, because I remember his blue lightsaber. I showed them how to get to the plaza. They destroyed the cannons and freed the prisoners (at least the ones who were still alive).

But the clone troopers? They never really left Ryloth. They took over our cities, just like the droids had done. This time, there wasn't an opposing army to stop them. Within a couple years they changed their armor and started calling themselves stormtroopers. Eventually the stormtroopers on Ryloth stopped looking identical when they took off their helmets. That was a relief, because for a long time, they looked exactly like the two friends who fed me when I was hungry and comforted me when I was scared.

But they weren't. I never saw those two troopers again. And the Imperials were *not* my brothers.

TOOLS OF WAR

1 **AT-RT:** The two-legged All Terrain Recon Transport was a one-pilot reconnaissance vehicle capable of reaching speeds of up to ninety kilometers per hour. Each AT-RT was outfitted with a repeating blaster cannon and a mortar launcher, though they were not typically used in direct combat roles.

2 **BLURRG MOUNT:** Thick-headed, bipedal reptilians, blurrgs were found on many worlds but thrived in the deserts of Ryloth. Cham Syndulla's raiders used blurrgs because they were fast and rarely tired.

3 **GUTKURR:** Gutkurrs were among the deadliest predators on Ryloth. Impervious to blaster fire because of their insect-like shells, they hunted in packs. The animals typically ignored droids and attacked organic beings, thus the Separatists released gutkurrs to clear out territories they controlled.

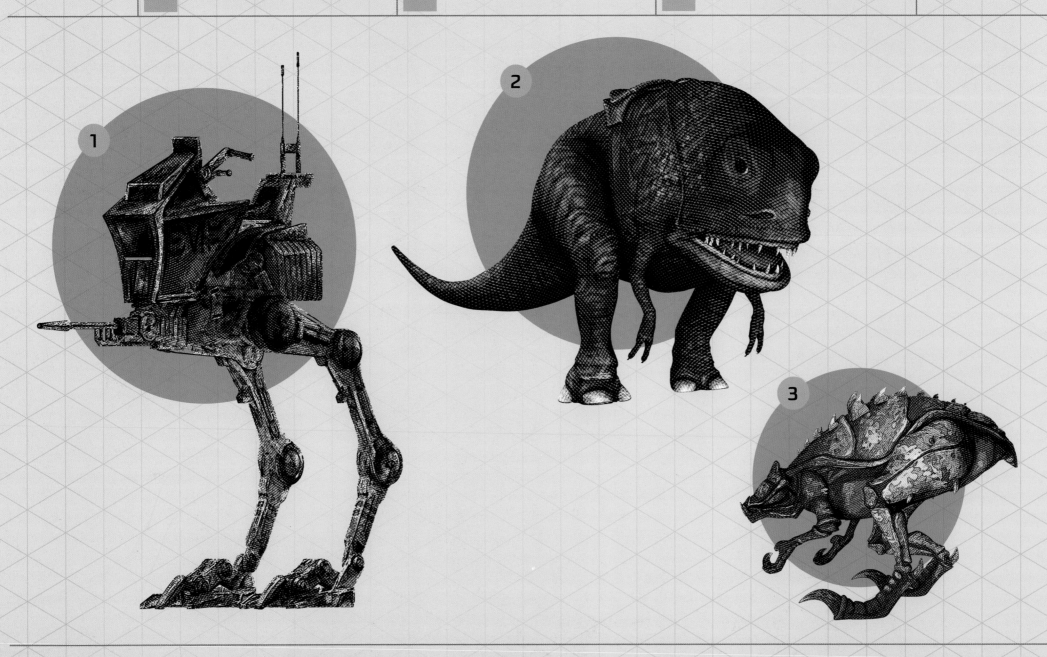

TOOLS OF WAR

4 **EMP GRENADE ("DROID POPPER"):** Commonly issued to clone troopers during the Clone Wars, EMP grenades released an electromagnetic energy blast, scrambling all electrical signals for three meters in every direction.

5 **HYENA BOMBER:** Patterned after the Vulture starfighter, the Separatist *Hyena*-class bomber had a wider profile and two command pods on its dorsal surface. Each Hyena bomber could carry four proton bombs, six proton torpedoes, and six concussion missiles in its bomb bay.

6 **J-1 PROTON CANNON:** The Separatists used J-1 cannons both as long-range artillery and as surface-to-air defensive turrets. Proton shells were manually loaded by a crew of battle droids, while the firing controls were operated by a battle droid pilot.

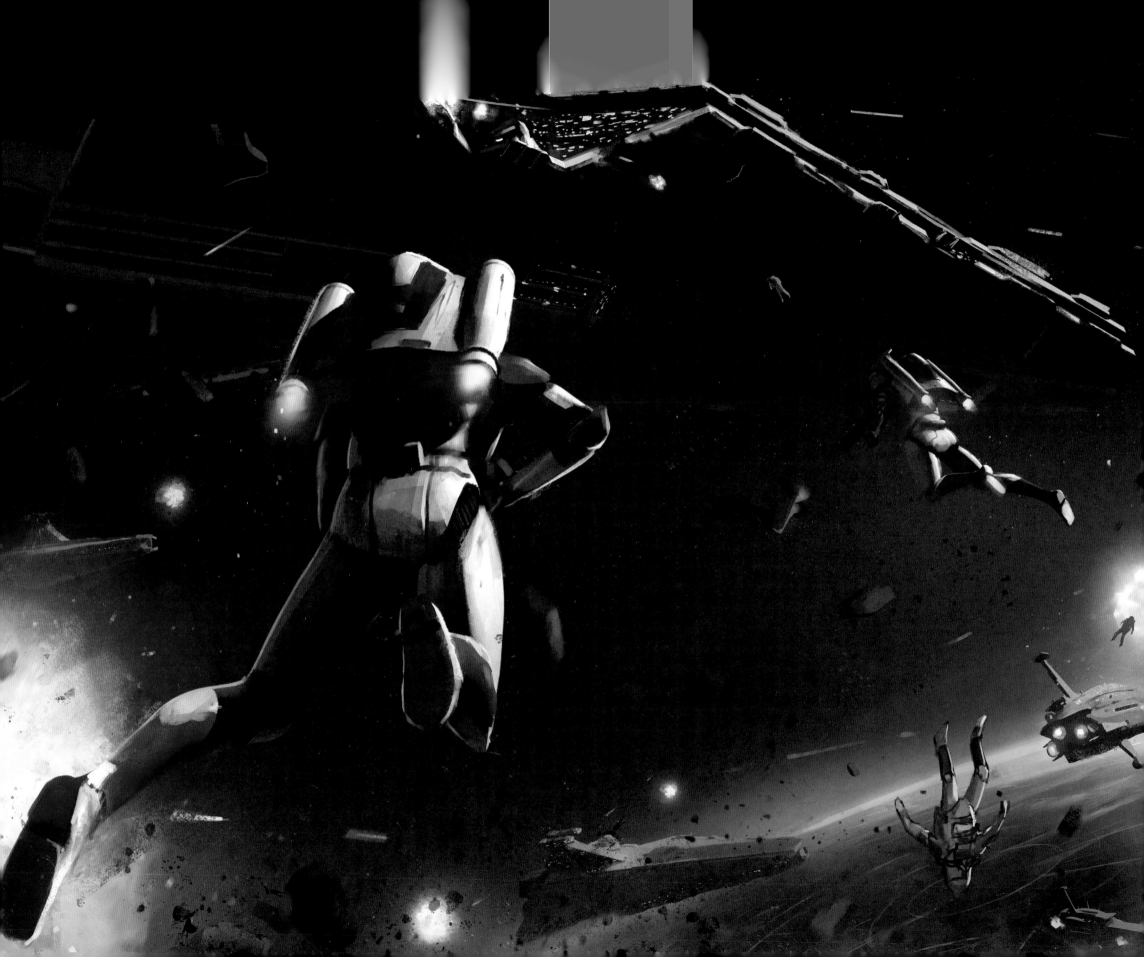

BATTLE OF CORUSCANT

- SPACE -

By year three of the Clone Wars, the Republic held all the momentum. The Separatists had been pushed back into the galaxy's spiral arms in a campaign dubbed the Outer Rim Sieges. In these fringe territories, Republic warships and Jedi commanders kept up the pressure, leaving the Republic capital of Coruscant with comparatively few defenses.

Not that this worried Republic strategists. The Separatists were on the run and couldn't risk a direct strike on the heart of the Republic. Such a move would result in defeat and likely mean the end of the Separatists as a military power.

The citizens of Coruscant knew it too. The Clone Wars had occurred far from their shores, and a Separatist surrender now seemed to be only a matter of time. Few officers in the Coruscant Home Defense Fleet had seen action, nor had they been drilled in countering a full-scale planetary attack.

The Separatists faced long odds; that much was undeniable. But by striking at Coruscant, they had a chance to inflict a surprising amount of damage while also scoring a shocking propaganda victory.

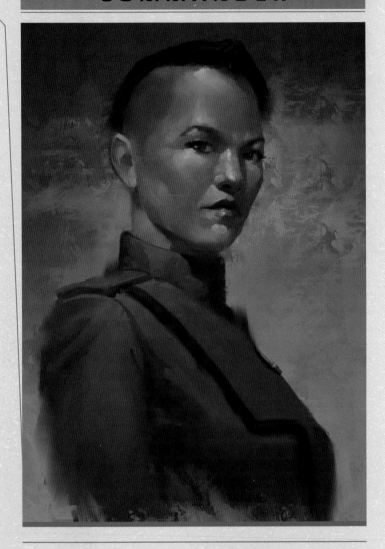

Battle of Coruscant
COMMANDER

CORUSCANT HOME FLEET COMMANDER HONOR SALIMA

A Coruscant native, Salima commanded its planetary defense force for a decade prior to the outbreak of the Clone Wars. She continued in her role throughout the war, gaining access to upgraded technology made available to her under the Republic's Military Creation Act.

PRELUDE TO BATTLE

The Separatists launched a surprise attack on Coruscant, but as it turned out, they had no intention of holding the planet. Instead, their naval flotilla only needed to provide cover for a strike team to reach the surface and pull off an audacious crime: the kidnapping of the Supreme Chancellor.

The initial stages of the battle played out exactly as the Separatists had hoped. Grievous and his armada dropped out of hyperspace and opened fire on the fleet of ships guarding Coruscant. A startled Republic wasn't fast enough to prevent Grievous from landing in the Executive District, killing the Chancellor's bodyguards and seizing Palpatine himself.

By the time Coruscant's home fleet had organized itself into attack formations, Grievous had already returned to his flagship, the *Invisible Hand*, with his captive in tow. But before Grievous could withdraw to the safety of hyperspace, Republic reinforcements dropped into the system and engaged their enemy.

If the Separatists escaped with their prisoner, the psychological fallout would be immense. Not only would the kidnapping expose the vulnerability of the Republic's capital, but it would also present the possibility that Supreme Chancellor Palpatine could be subjected to a sham trial broadcast across the galaxy—one that would most likely end with his execution. That threat would be enough to drive Republic High Command to the negotiating table and offer up deep concessions to the Separatists.

For this reason, the Republic made the *Invisible Hand* its prime target. The Coruscant Home Fleet moved to cut off the hyperspace jump point, buying the time needed for a rescue squad to execute a daring boarding raid against the Separatist flagship.

TACTICAL ANALYSIS

Rescuing the Chancellor became the Republic's top priority. The plan was for renowned Jedi commanders Obi-Wan Kenobi and Anakin Skywalker, escorted by the elite pilots of Clone Flight Seven, to board the *Invisible Hand* and retrieve its high-value prisoner.

But first the rescue mission required the Jedi penetrate a thick screen of starfighters, buzz droids, and support frigates arrayed in a defensive formation around the *Invisible Hand*. At the same time, Separatist *Recusant*-class warships, Trade Federation battleships, and *Munificent*-class star frigates fought the Republic for their very survival. The Republic's home fleet and its frontline reinforcements consisted largely of *Venator*-class Star Destroyers, and they made an aggressive push to trap and destroy as many Separatist capital ships as possible.

> "THE CLASH BETWEEN BATTLESHIPS BECAME A SLUGGING MATCH, WITH HEAVY CASUALTIES ON BOTH SIDES."

The clash between battleships became a slugging match, with heavy casualties on both sides. Naval vessels made close passes as they fired turbolaser broadsides. Before long, the larger ships began venting atmosphere from hull punctures. Smaller frigates broke apart completely, their fragments becoming drifting space hazards. Small bands of vacuum-suited clone troopers jetted through the void, boarding damaged warships to seize control of their bridges.

Through all this, Masters Kenobi and Skywalker wove their Eta-2 *Actis* Interceptors toward Grievous's ship. They

landed inside the *Invisible Hand* to find the Chancellor was being held in its conning tower. Count Dooku's presence aboard the Separatist flagship proved to be a stroke of good fortune for the Republic. His death at Skywalker's hands left the Confederacy of Independent Systems without its leader, founder, and most potent political symbol.

Even with the Chancellor in custody, they could not escape the *Invisible Hand*, as Grievous had jettisoned the ship's escape pods. Instead, Skywalker opted to steer the kilometer-long warship to a safe berth on the planet below.

But the *Invisible Hand* had taken a severe beating from the guns of the *Venator*-class Star Destroyer *Guarlara*. As its hull sagged under the pull of Coruscant's gravity well, the ship's internal gravity randomly switched polarities. When its tensor fields finally failed, the *Invisible Hand* split amidships. As its stern tore away, its forward section became a plummeting wreck. Despite the impossible aeronautical challenge, Skywalker brought the broken warship to a stop on one of Coruscant's emergency runways.

The Separatist frigate *Profusion* recovered Grievous's escape pod. With his prize ripped from his fingers, the general ordered all Separatist vessels to flee the battlefield.

Many Separatist ships could not follow Grievous to safety. A full third of the Separatist armada had sustained critical ship failures or had suffered engine damage that prevented hyperspace escape. Larger capital ships—the ones under the command of Neimoidians,

> **"WITH HIS PRIZE RIPPED FROM HIS FINGERS, THE GENERAL ORDERED ALL SEPARATIST VESSELS TO FLEE THE BATTLEFIELD."**

Muuns, and other organics—surrendered. Droid star-fighters did not. The Republic's clone pilots spent hours sweeping the space above Coruscant, clearing out any lingering Vulture droids, Hyena bombers, and droid tri-fighters.

AFTERMATH

The Battle of Coruscant proved to be the Separatists' last gasp. The decimation of their fleet, combined with the death of Count Dooku, left them with few assets they could call their own.

General Grievous succeeded Dooku as the Confederacy's de facto head of state but lasted in that role for only a few days. Grievous died on Utapau at the hands of Obi-Wan Kenobi, and the Separatist Council met their fates on Mustafar soon after.

In the wake of Coruscant, Palpatine activated the final, deck-clearing stage of his Clone Wars power play when he issued Order 66. The clone troopers turned against the Jedi and stormed the Jedi Temple, setting fires that gutted the ancient sanctuary. By demonstrating that dangers existed close to home, the Battle of Coruscant helped ensure that Palpatine faced almost no popular opposition in his unprecedented establishment of a central authority and a vastly expanded military.

Palpatine now had no one to check his power or oppose him, at least no one who could mount a challenge. Before the Senate he announced the formation of the First Galactic Empire, with himself as Emperor.

The war was over. The galaxy had achieved peace, at the cost of freedom.

GENERAL GRIEVOUS

Kaleesh cyborg and supreme military commander of the Separatist droid armies, General Grievous had an obsession with collecting lightsaber trophies from the Jedi Knights he killed in combat.

COMBATANTS

1 SEPARATIST DROID CREWERS: Most crew positions on Separatist warships were filled by specialized battle droids, but this varied depending on the Separatist faction in question. Neimoidians often crewed the Trade Federation vessels, and Gossams could typically be found aboard Commerce Guild destroyers.

2 CLONE PILOTS: On Kamino, some clone troopers received special pilot training of starships and airspeeders. These craft included the LAAT gunship, the V-19 Torrent starfighter, the Z-95 Headhunter starfighter, and the ARC-170 assault fighter. Elite clone pilot squadrons often served directly under Jedi commanders.

3 JEDI PILOTS: During the Clone Wars, skilled Jedi Knights used their Force-attuned reflexes to become superb combat pilots. At the start of the fighting, most of them flew Delta-7 Aethersprite starfighters. By the war's close, the Eta-2 light interceptor had become the Jedi starship of choice.

Clone Pilot Odd Ball

CORUSCANT

Postmission summary from the Coruscant action; CC-2237, also known as Odd Ball, reporting.

Clone Flight Squad Seven launched from the carrier *Ro-Ti-Mundi*. Our mission was to escort Jedi generals Obi-Wan Kenobi and Anakin Skywalker to the Separatist flagship *Invisible Hand* and cover them while they executed a boarding action.

Once we hit space I ordered Squad Seven's V-19s to take point. The Seps were on us as soon as we shook the dust from our wings. The V-19s punched a hole through the droid tri-fighters that tried to block our advance. Lost two pilots.

I brought up my ARC-170 to tail the Jedi and ordered the other heavy hitters to do the same. By riding in their slipstream, we could thread the needle through the Seppie screen while laying down supporting fire—but those Etas kept flying out of range. We boosted our afterburners to keep up. That was all on Skywalker. Had to be.

Seppie vulture droids hit us in the next screen. We evaded the homing missiles. The buzz droids? Those were a bit of a problem. The biters disabled one ARC, killing its engines and sending it on a path that took it out of the action. A second ARC lost its weapons and had to return to the *Ro-Ti-Mundi*. I could see that

Skywalker and Kenobi were having their own troubles with the buzz droids, but by the time Squad Seven caught up they'd shaken them.

The commanders reached the *Invisible Hand* and landed in her hangar bay, which meant that our mission was complete. I ordered Squad Seven to eliminate targets of opportunity but to stay close in case Kenobi and Skywalker needed cover on their way out.

After a while the *Invisible Hand* dropped out of orbit, and then the blasted thing broke clean in half.

Truth is, I didn't expect either of the commanders to survive. But that's Jedi for you.

TALES OF VALOR

R2-D2

A simple astromech droid assigned to Anakin Skywalker's Eta-2 starfighter played a critical role in the Republic's victory at the Battle of Coruscant. It's true that most droids don't earn such accolades, but most droids aren't R2-D2.

Once a member of Queen Amidala's droid pool on Naboo, the blue-and-white astromech unit specializes in repair and astronavigation. He received a royal commendation for helping the Queen's starship break a Trade Federation blockade. At the start of the Clone Wars, Amidala passed the droid on to Skywalker, who used him as a starfighter plug-in. R2's lack of regular memory wipes—which are recommended by droid manufacturers to improve focus and performance—allowed him to develop an idiosyncratic connection with Skywalker's starfighter. He also forged a "comrades-in-arms" bond with Skywalker himself.

During the Battle of Coruscant, R2 fought off the buzz droids that swarmed Skywalker's ship (Obi-Wan Kenobi's droid, by contrast, suffered fatal damage) and assisted in the infiltration of the Separatist flagship *Invisible Hand*. Notable among R2-D2's many achievements: dousing super battle droids with oil and setting them ablaze, splicing into the *Invisible Hand's* computer system to seize control of its turbolifts, and distracting General Grievous's MagnaGuards by deploying every tool packed into his chassis at the same time.

Had R2 failed at any task, the mission to retrieve the Chancellor would have ended in disaster. The Republic owes a lot to this little droid.

TOOLS OF WAR

1 **ETA-2 STARFIGHTER:** The Eta-2 *Actis*-class interceptor, used by Jedi pilots toward the end of the Clone Wars, was an early predecessor to the Empire's TIE starfighter. It lacked both a hyperdrive and a shield generator, which resulted in a compact profile, but it could still hit back with laser cannons and ion cannons.

2 **ARC-170:** Also known as the Aggressive ReConnaissance-170 starfighter, the ARC-170 was a favorite of clone pilots charged with eliminating Separatist capital ships. The fighter carried six proton torpedoes in addition to rear-mounted laser cannons and heavy laser cannons mounted on each wingtip. The ship required a crew of three: a pilot, a forward gunner, and a tail gunner.

3 **V-19 TORRENT STARFIGHTER:** The Republic deployed the V-19 starfighter late in the Clone Wars. Designed for assault roles, the V-19 offered impressive speed and maneuverability thanks to its folding S-foils. Clone pilots could fight back with the V-19's wingtip laser cannons as well as twin concussion missile launchers.

4 **BUZZ DROID:** Also known as the Pistoeka sabotage droid, the buzz droid was a type of self-aware payload carried aboard discord missiles. Upon deployment, a horde of buzz droids would swarm across a targeted starship, securing firm footing on the enemy's hull and unfolding an array of sabotage weapons, including circular saws, drill heads, pincer arms, and plasma torches.

5 **INVISIBLE HAND:** General Grievous's flagship, the *Invisible Hand* was a specially modified *Providence*-class carrier/destroyer. Its upgrades included a luxurious command deck, and the ship could attack with multiple turbolaser turrets, laser cannons, ion cannons, flak cannons, and proton torpedo launchers.

6 **DROID TRI-FIGHTER:** A compact, heavily armed Separatist starfighter, the droid tri-fighter had a profile defined by three arms that surrounded a rotating, gyroscopic core. In addition to a central laser cannon and three laser cannons on its arms, the tri-fighter carried a payload of proton torpedoes, concussion missiles, or buzz droids.

7 **VULTURE STARFIGHTER:** The Variable Geometry Self-Propelled Battle Droid saw action at the Battle of Naboo and became a mainstay of Separatist starfighter squadrons. Each Vulture starfighter was armed with four blaster cannons and two torpedo launchers and could transform into a four-legged walking configuration when not in flight.

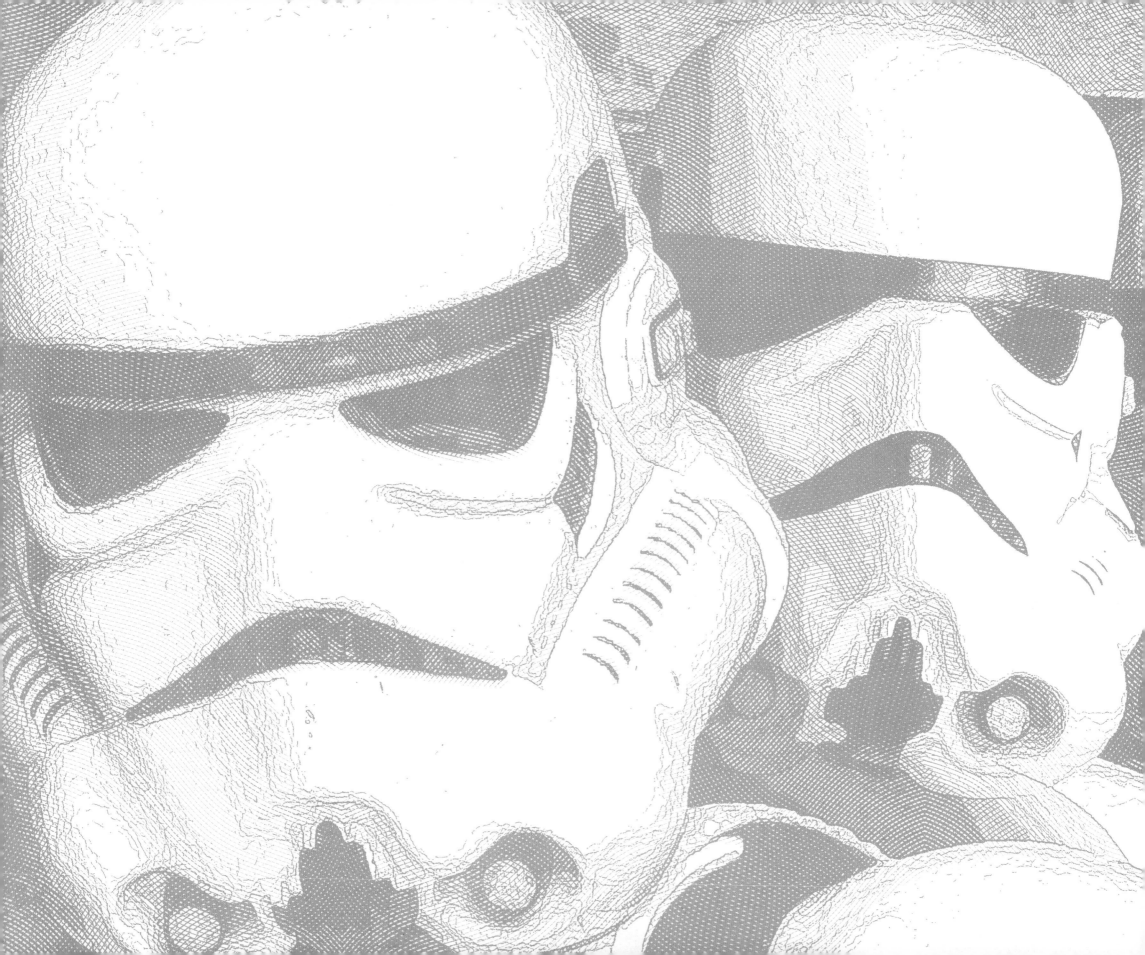

PART II
THE GALACTIC CIVIL WAR

ONLY DAYS AFTER the birth of the Galactic Empire, Palpatine began consolidating his rule through force of arms. Soon, Star Destroyers and TIE fighters patrolled the stars and white-armored stormtroopers kept a close watch on the citizenry. Military omnipresence offered the promise of security, but came with an unspoken threat: *don't become our enemy*.

Totalitarianism breeds suspicion. Those judged as deficient in their loyalty to the Emperor risked imprisonment, seizure of property, and death. For years, Imperial rule was absolute.

But cracks in the monolith began to show. Every world had its dissidents. On Ryloth, Cham Syndulla urged his people to fight their Imperial occupiers. On Lothal, a small rebel cell made an outsized impact through sabotage and propaganda jamming. In deep space, the A-wings of Phoenix Squadron raided the Empire's convoys and kept one jump ahead of pursuing Star Destroyers.

Those sympathizers who understood politics—in particular, Senator Bail Organa of Alderaan and Senator Mon Mothma of Chandrila—took steps to unite the isolated cells of anti-Imperial resistance. This became the Rebel Alliance, formally known as the Alliance to Restore the Republic.

It took nearly two decades for the Rebellion to assemble a navy and a military command structure, but even then the rebels had no real hope of defeating their vastly more powerful enemy. The Empire's brand-new tool of domination, the Death Star, had the means to destroy planets. With the massive space station entering the field of battle, shutting it down represented the Alliance's only hope of survival.

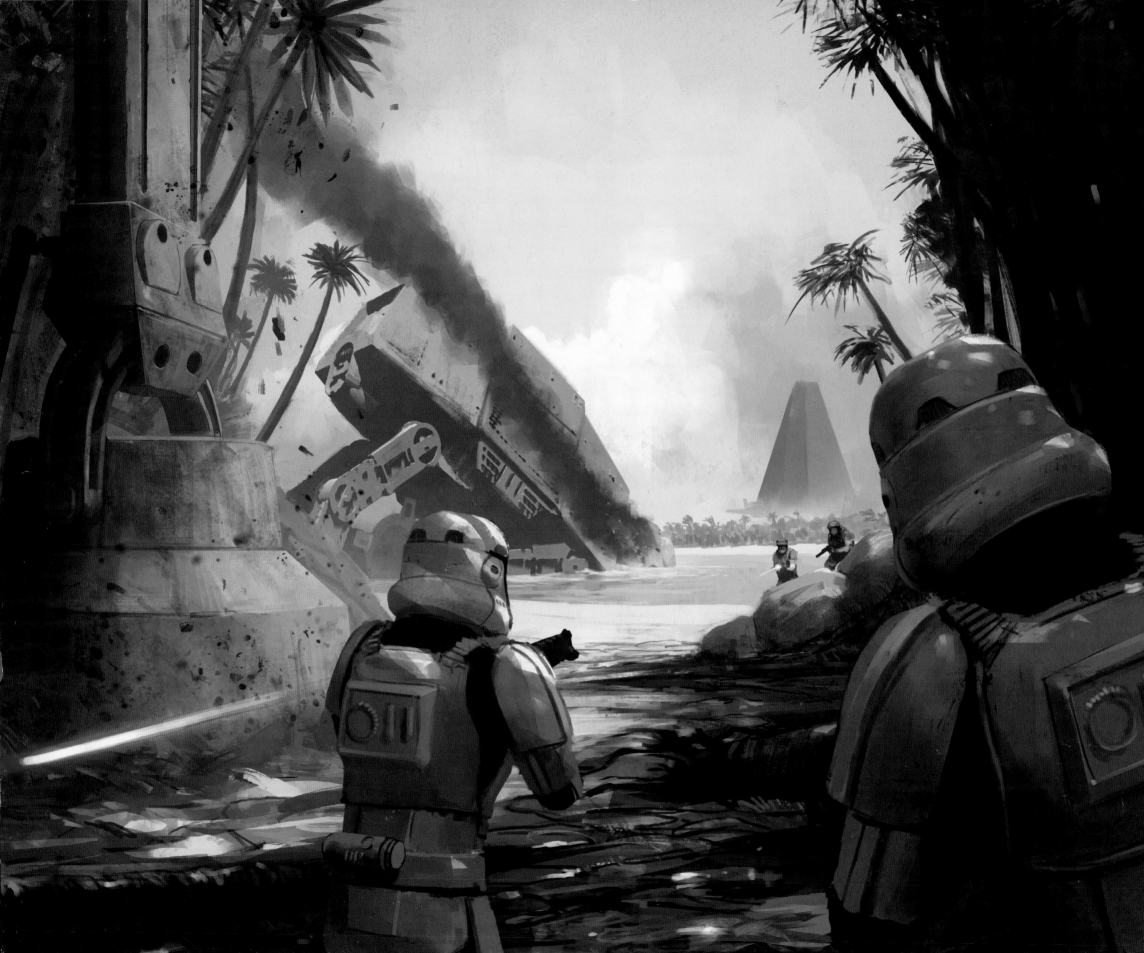

BATTLE OF SCARIF
- GROUND AND SPACE -

It may have been the Rebellion's first victory against the Galactic Empire, but in truth the Battle of Scarif was never supposed to happen. The Alliance to Restore the Republic had been fighting the Empire with guerilla tactics and subversion for many years prior to the battle, but in almost every way their fight was still in its infancy.

Even with their gathered intelligence, the Alliance was not prepared to face the unthinkable weapon the Empire had developed. Divergent factions and ideological differences within the Alliance paralyzed its ability to form a united front and act. It was the Alliance's newest recruit, refusing to obey orders, that plunged the Rebellion into overt conflict and forced it to face

an enemy it wasn't prepared to fight.

The Empire's dogged pursuit of absolute power necessitated extreme steps, but it was their overconfidence that created an opening. Thus the Battle of Scarif arose from the daring actions of a few who defied the odds and the military might of the Empire in a bid to secure a prize that held the Alliance's only hope for survival.

COMMANDER

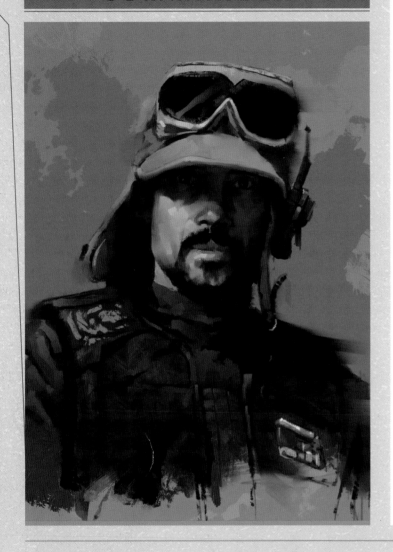

PRELUDE TO BATTLE

Rumors of an Imperial defector on Jedha intrigued Alliance Intelligence, especially when they learned the fugitive possessed knowledge of a supposed Imperial "planet killer." But getting near the prize required working with Saw Gerrera, a guerilla who had cut ties to the Alliance years before. Alliance Intelligence elected to forcibly recruit a new operative: one with ties to both Saw Gerrera and the superweapon's mastermind, Dr. Galen Erso.

This was Jyn Erso, and she had what the Alliance needed. The Empire, however, responded by leveling Jedha's Holy City with a blast from the Death Star's superlaser. This proof of the enemy's incalculable firepower rattled the rebel council, shattering any hope at consensus.

Jyn Erso didn't have time to wait. Going behind the council's back, she gathered volunteers for a raid on Scarif, site of the data vault housing the Death Star schematics. The renegades flew under the call sign "Rogue One," and when news of their mission reached the Alliance's leaders, they sent their entire fleet to Scarif to assist.

Inaction was no longer an option.

TACTICAL ANALYSIS

Jyn Erso's squad arrived at Scarif in the hold of an Imperial cargo shuttle, which allowed them to pass through the shield gate and touch down on one of the landing pads ringing the Citadel Tower. A small unit—Erso, Captain Cassian Andor, and the reprogrammed Imperial security droid K-2SO—set out to retrieve the Death Star plans from the tower's data vault.

Meanwhile, Sergeant Ruescott Melshi led his commandos to spread out among the landing pads to plant explosives as part of a staged distraction. Shuttle pilot Bodhi Rook remained with the ship to act as a getaway driver.

Melshi's commandos kicked off the fireworks by busting the trooper barracks near Pad 12. The provocation forced a response from Scarif's General Ramda, who threw excessive resources at the disturbance in an effort to impress the visiting Orson Krennic, Director of Imperial Weapons Research. In minutes, shoretroopers, AT-ACTs, and TIE strikers zeroed in on Pad 12, even as Bodhi Rook roiled the pot with reports of non-existent rebel attacks at other pads. Ramda, panicked, sent his forces in a dozen different directions.

In space overhead, the rebel fleet dropped from hyperspace and formed a battle formation around Admiral Raddus' flagship *Profundity*. X-wings, Y-wings, and U-wings launched from every hangar bay, plotting attack vectors on the twin Star Destroyers guarding Scarif's planetary shield.

A handful of starfighters slipped through the shield gate and reached the surface of Scarif, but most fighters remained trapped in orbit on the other side of the invisible barrier. But if Admiral Raddus could smash the shield gate, the Rogue One team could escape—and could also relay a data-heavy transmission like the Death Star's full technical readouts.

SERGEANT RUESCOTT MELSHI

Leader of the Alliance's Pathfinder commandos in the mission on Scarif, Melshi was a practical and combative commander accustomed to improvisation when faced with long odds.

ADMIRAL RADDUS

Though he hailed from Mon Cala's polar regions, Admiral Raddus was surprisingly hotheaded. He was impatient with diplomacy and believed the Empire needed to be stopped before it grew even stronger.

The Imperial defenders gained momentum through numerical advantage. Blue Squadron's X-wings took out AT-ACTs and TIE strikers, but it couldn't turn the tide against the Imperial horde bearing down on Sergeant Melshi's besieged commandos.

In desperation, Admiral Raddus ordered his Y-wings to make a bombing run on one of Gorin's Star Destroyers, disabling it with ion charges. Then, positioning one of his Hammerhead corvettes, he nudged the lifeless warship into a collision course with its twin. The stricken Star Destroyers spiraled into the shield gate and ripped it to shreds.

Inside the Citadel Tower, Jyn Erso and Cassian Andor pulled the Death Star data-tape from deep storage. Erso, her prize in hand, ascended to the tower's peak to transmit their data via the communications antenna. Director Krennic was acutely aware insurgents were after the plans, but his attempt to stop Erso from transmitting the data to the awaiting rebel fleet failed.

The *Profundity* received the Death Star transmission, but by then the actual Death Star had arrived in the Scarif war zone. On the orders of Grand Moff Tarkin, the battle station fired a single-reactor superlaser shot at the planet below.

The supremacy of the Death Star was undeniable. No force in the galaxy could withstand such a blast. Every living being for hundreds of kilometers surrounding the Citadel Tower died instantly—rebel and Imperial alike.

The Empire continued tactical pressure, disabling the *Profundity* as it tried to flee. Darth Vader led the boarding party, decimating the rebel crewers. One soldier survived long enough to place the Death Star plans onto a datacard and deliver it to Princess Leia Organa of Alderaan. Her ship, the *Tantive IV*, then jumped to hyperspace.

AFTERMATH

Despite the Imperial overkill at Scarif, the data leak had not been plugged. Darth Vader caught up with the *Tantive IV* over Tatooine, yet the Death Star plans proved maddeningly elusive.

Having the plans in rebel hands presented two risks. One was the potential discovery of a flaw in the station's design. Another, more worrying risk was the potential that the Rebellion might expose the Death Star project to the Senate and the newsnets, triggering a governmental crisis and shaking public faith in Palpatine's benevolence.

The Empire couldn't lose control of the narrative. It was far easier to preemptively shut down the opposition. And thus, two stunning events occurred in short order: the dissolution of the Imperial Senate and the annihilation of the dissident planet Alderaan—abruptly silencing any dissenting voices.

Perhaps naively, Mon Mothma had hoped to use the Senate's apparatus to publicly air Palpatine's crimes. Now all political avenues were closed. Armed conflict was the Rebellion's only option.

> "NO FORCE IN THE GALAXY COULD WITHSTAND SUCH A BLAST."

ADMIRAL GORIN

The Imperial commander of the space above Scarif. Gorin led the initial defense of the planet but eventually ceded his authority to Grand Moff Tarkin.

GENERAL SOTORUS RAMDA

Ramda, the cautious, by-the-book commander of the Scarif Citadel, hoped for a plush Core World assignment and feared any rash action that might jeopardize his future. He rejected the possibility that outlaws could penetrate Scarif's planetary shield or elude Citadel security.

COMBATANTS

1 **DEATH TROOPERS:** Death troopers were elite soldiers recruited by Imperial Intelligence. The reflec coating on their armor warped electronic signals, rendering them nearly invisible to sensor scans.

2 **SHORETROOPERS:** Scarif's coastal defender stormtroopers were elite units who outranked standard infantry stormtroopers. Their lightweight armor was optimized for climate control and water resistance.

3 **IMPERIAL SECURITY DROIDS:** The KX-series security droids stationed at the Citadel were coated in a durable carbonplast composite and armed with blaster rifles. Communications booster packs allowed them to signal for reinforcements.

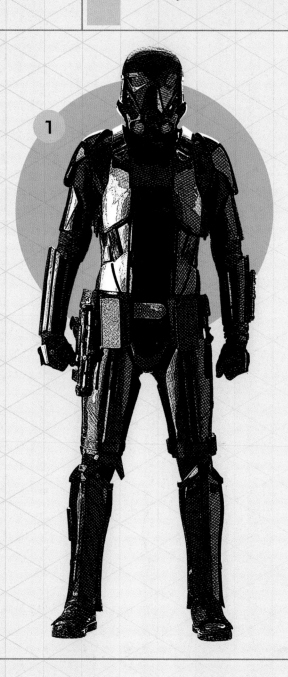

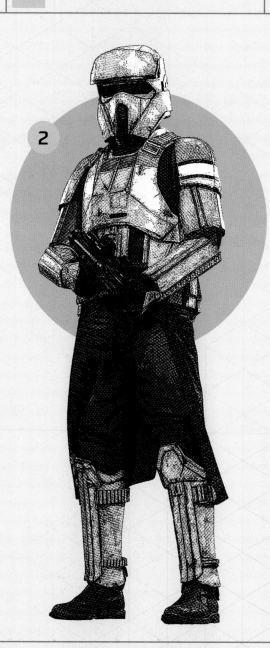

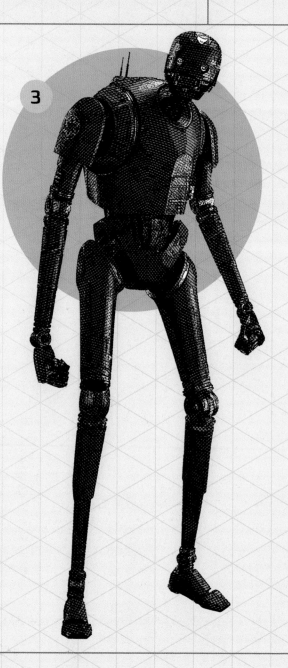

COMBATANTS

4 **TIE STRIKER PILOTS:** Elite naval officers assigned to Scarif's Advanced Weapons Research division, TIE striker pilots excelled in the tricky art of atmospheric combat.

5 **REBEL INFILTRATORS:** Many groundside fighters on Scarif belonged to the Pathfinders, a unit of Rebel SpecForces made up of snipers, spotters, scouts, survivalists, and demolitions experts.

6 **U-WING PILOTS:** Each U-wing required two pilots to steer the craft into hot landing zones and operate its two laser cannons. U-wing pilots were versatile, often boasting SpecForces experience to round out their cockpit skills.

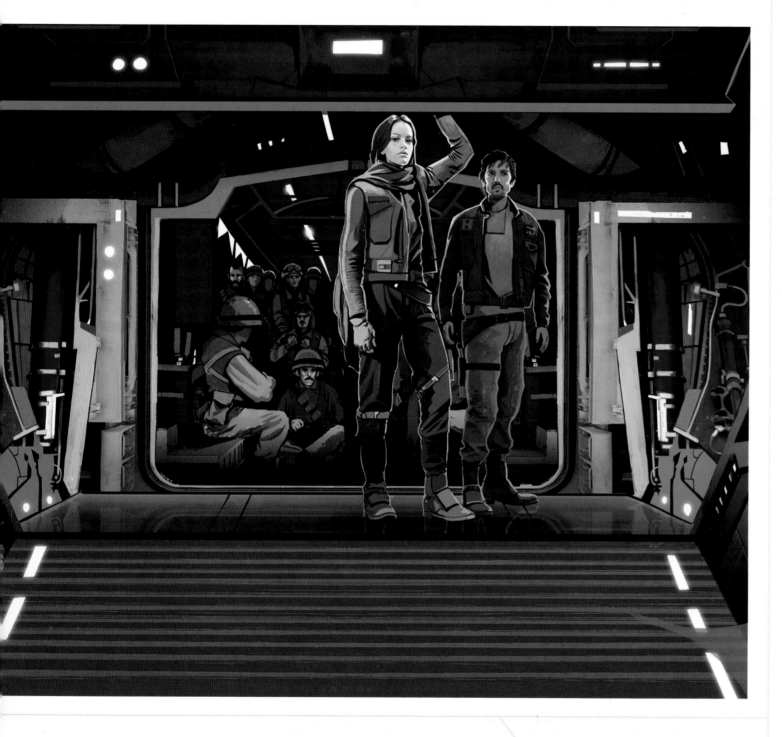

Jyn Erso

Jyn Erso's tenure with the Rebel Alliance can be measured in days, yet her impact will be felt for generations.

The daughter of an Imperial weaponsmith, Erso found herself on the run at the age of eight after Orson Krennic of the Empire's research division forced her father back into service. To survive, she joined Saw Gerrera and his brutal insurgents.

She eventually split from Gerrera and cycled through a string of disposable identities, populating a database with criminal offenses. While imprisoned at an Imperial labor colony, the Alliance commandos who sprung her gave her a conditional offer of freedom. Under "Operation Fracture," Erso would leverage her status as Dr. Galen Erso's daughter while calling in favors from Saw Gerrera's outlaws. It was an ultimatum that forced Erso to revisit her long-faded emotional bonds.

Erso succeeded in securing the intelligence from Gerrera, but her conscience led her to an Imperial work camp on Eadu in an attempt to free her father. Convinced that Dr. Erso's death would rob the Empire of a critical asset, the Alliance chose to level the facility and called in a bombing raid. Galen Erso died in his daughter's arms.

Though Jyn Erso had justification to turn her back on the Rebellion, she instead tried to convince the rebel council to back an all-out strike on Scarif to retrieve the Death Star blueprints and find the fatal flaw her father had engineered into its design. The council refused.

Defiantly, Jyn Erso recruited her own team. Those who pledged themselves to the "Rogue One" mission were full of hope, and in Jyn Erso they saw a leader who acted with conviction.

Had it not been for Erso's brash gamble, the Death Star's weakness would have gone undetected, and the rebels would have lost the Battle of Yavin.

Jyn Erso's death is a tragedy. The galaxy will never know how she might have shaped the Rebellion in the years that followed.

Lieutenant Buscon, Communications Officer aboard the *Consonance*

SCARIF

My name is Lieutenant Lune Buscon, COMMO of the RHA Hammerhead corvette *Consonance*. My vessel jumped to Scarif with the rest of the fleet. In the end, we were one of the few that jumped to safety. We left Scarif behind. Scarif, where they died.

Everyone in the Alliance should know who they are now. We've memorialized them and named things after them. But I feel like I might be the only living person who knows how they died.

During battle, it's the job of the COMMO to monitor transmissions between ships of the fleet. The planetary shield meant I wasn't getting anything from below, but I kept freq-hopping until I was able to eavesdrop on some of the Imperial chatter. These fragmentary transmissions must serve as a record of their actions.

[SCARIF ADMINISTRATIVE]: Reporting a rebel starfighter incursion before shield seal. X-wing and U-wing configuration.

FREQ 997745.009 [SCARIF ADMINISTRATIVE]: Scarif garrison, we have rebel starfighters inbound. Scramble the TIE strikers.

FREQ 997776.082 [SCARIF PATROL]: AT-ACT Berm One reporting. Rebels are in full retreat from Pad Twelve. Three walkers are in position and more are on the way.

FREQ 997776.082 [SCARIF PATROL]: We're taking damage! We're not armored for this. Where are those strikers?

FREQ 997702.099 [SCARIF ORBITAL]: Admiral, the rebels are bombing the shield ring. Permission to launch the gate's TIE squadrons.

FREQ 997737.016 [SCARIF AIR TRAFFIC]: All Strikers, this is Black Leader. Rebel starfighters are in position to shield infantry from air attack. Pick your targets and engage.

FREQ 997737.016 [SCARIF AIR TRAFFIC]: There's a U-wing unloading troops at mark Seven. Take it out, Striker Two.

FREQ 997792.018 [SCARIF CUSTOMS]: This is the Pad Nine controller, reporting an ambush on Pad Nine. Repeat, active firefight on Pad Nine.

FREQ 997745.005 [SCARIF ADMINISTRATIVE]: Pad Nine, we are detecting an unauthorized surface-to-orbit transmission originating from your location. Eliminate cargo shuttle SW-0608, highest priority.

FREQ 997745.005 [SCARIF ADMINISTRATIVE]: Comms tower main dish is broadcasting. Transmission is underway. Recipient appears to be . . . the rebel flagship.

FREQ 997745.003 [SCARIF ADMINISTRATIVE]: All surviving Strikers, take out that dish!

FREQ 997745.005 [SCARIF ADMINISTRATIVE]: Scarif Citadel hailing Death Star. We request immediate assistance. We need TIEs in orbit and troops on the surface at once.

FREQ 997745.005 [SCARIF ADMINISTRATIVE]: Scarif Citadel hailing Death Star. Please acknowledge.

Though their final words will never be recorded, I bore silent witness to their sacrifice. I hope that one day we may understand the events that transpired on Scarif.

TOOLS OF WAR

1 **AT-ACT:** The All Terrain Armored Cargo Transports on Scarif were larger than dedicated combat AT-ATs. Their bodies were built to carry removable cargo modules, and each was armed with two heavy laser cannons.

2 **TIE STRIKER:** The experimental TIE/sk was designed on Scarif for atmospheric defense of Imperial groundside garrisons. It was armed with six laser cannons, and its cockpit housed a pilot and a bombardier.

3 **TIE REAPER:** This specialized, armed carrier craft was specifically designed for inserting troopers into battle situations while withstanding sustained fire from heavy guns.

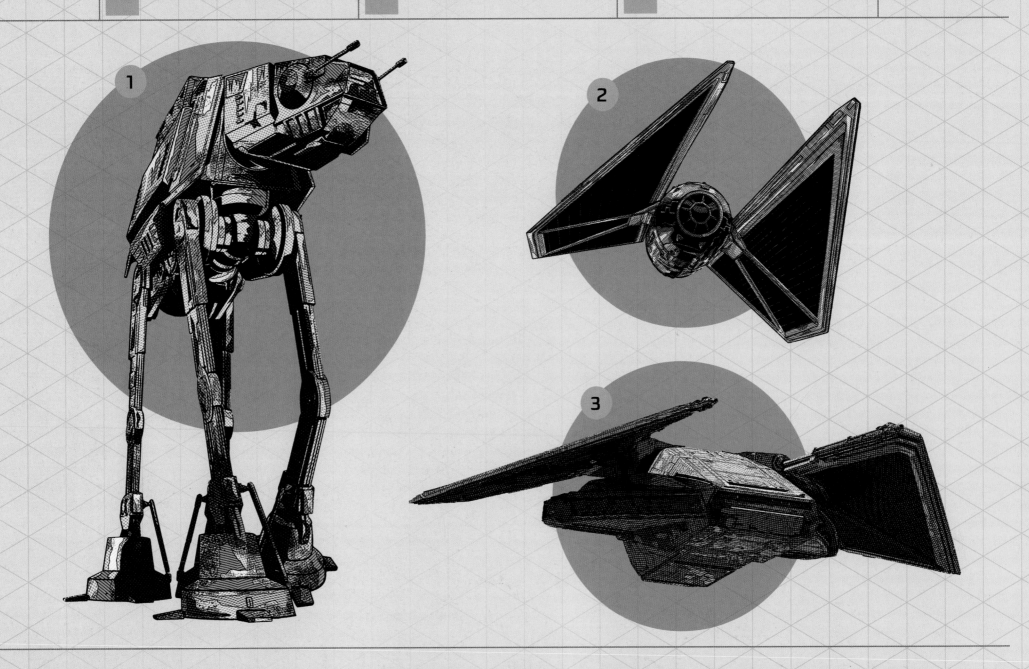

TOOLS OF WAR

4 **DEATH STAR:** The Empire's technological terror, the Death Star battle station rivaled a small moon in scale. At full power, its primary weapon could destroy an entire planet.

5 **PROFUNDITY:** Admiral Raddus's personal flagship, the *Profundity* was one of the first Mon Cal craft to be converted into a combat vessel. More than 1200 meters long, it was operated by a crew of better than three thousand.

6 **U-WING:** Both a gunship and a troop transport/medevac, the UT-60D U-wing starfighter was a heavily-shielded ship that could carry up to eight soldiers. When flying air support, gunners often fixed cannons to a U-wing's open door ports for strafing ground targets.

4

5

6

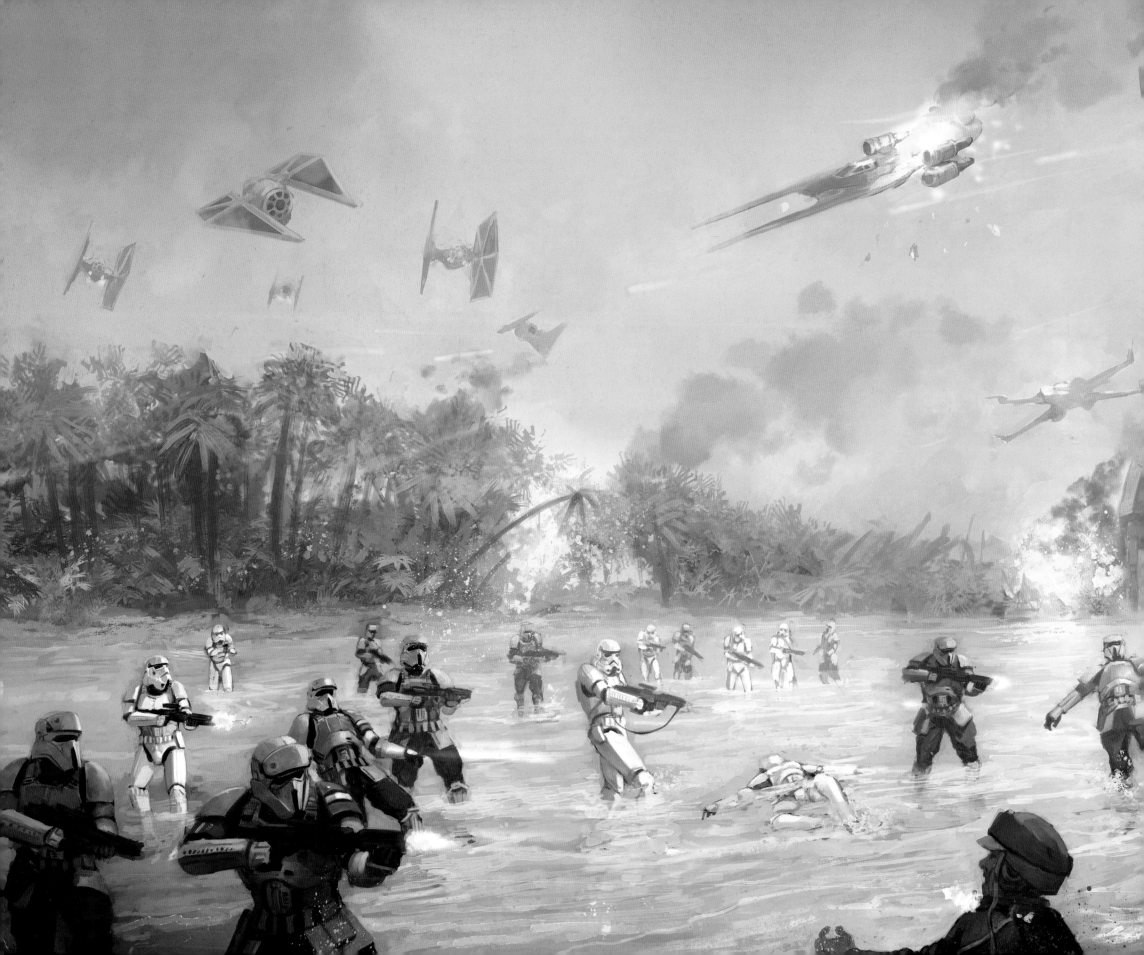

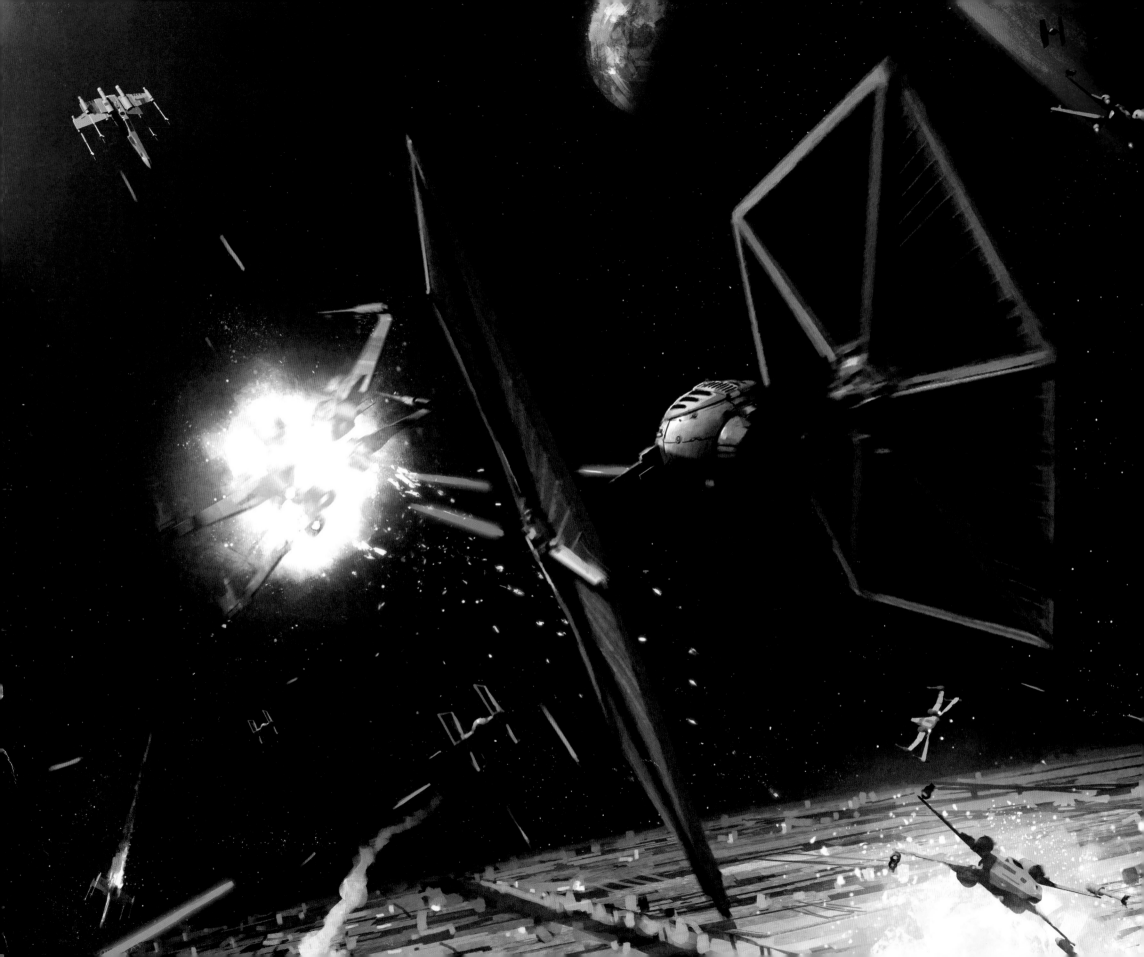

BATTLE OF YAVIN

- SPACE -

The Rebel Alliance didn't have the personnel, the equipment, or the experience to defeat the Empire on an open battlefield. Instead it relied on hit-and-fade raids and the interplay of stealth and surprise. In the eyes of most, the Alliance's victory in capturing the Death Star plans was a lucky shocker: a confluence of fortunate breaks that would never be repeated.

Despite the security breach, construction of the Death Star continued unabated. Imperial engineers soon issued the good news: after nearly two decades, the Death Star was finally finished. The battle station's commander, Grand Moff Tarkin, now held the power of life and death on a planetary scale.

Alderaan, a prominent Core World with a reputation for disloyalty, became Tarkin's first example of the consequences of dissidence. Two billion people died when the planet was destroyed.

Tarkin arguably could have stopped there without ever needing to fire a second shot. Over time, worlds living under the fear that they might suffer Alderaan's fate would likely have withdrawn the financial support that had made an organized rebellion possible. But Tarkin wouldn't rest until he obliterated the Rebel Alliance. A homing beacon soon gave him what he sought: the coordinates of the Rebellion's headquarters.

Battle of Yavin
COMMANDER

GENERAL JAN DODONNA

Dodonna served in the Republic military during the Clone Wars but retreated to his homeworld of Commenor rather than become a part of the hated Imperial Navy. Mon Mothma later recruited him into the Rebel Alliance.

PRELUDE TO BATTLE

The Death Star dropped from hyperspace into the Yavin system, entering into orbit around a giant gas planet. The rebel base lay on a jungle moon on the planet's far side.

The rebels launched a last-ditch counterattack. With two squadrons of starfighters and a hastily conceived long-shot plan, the rebels' only chance was to hit a small thermal exhaust port on the battle station with proton torpedoes. The hope was that a single lucky torpedo would travel all the way to the reactor.

For Grand Moff Tarkin and the Empire, the Rebel Alliance's high command would soon be annihilated by the superlaser—an act that would more than atone for the loss of the Death Star plans. Their decisive victory would resound for decades, and the galaxy would realize that defying Imperial rule was not only futile, it was fatal.

TACTICAL ANALYSIS

The rebels had no heavy warships at Yavin 4. They didn't even have enough transports to evacuate the base. The only assets at their disposal were two squadrons of aging snubfighters. The Y-wing bombers of Gold Squadron seemed the best fit to make a targeting run on the Death Star's exhaust port, thus the X-wings of Red Squadron would have to provide cover.

By any honest accounting, the Rebel Alliance's chances were infinitesimal. Yet those odds were decidedly in their favor. Rebel tacticians had projected that small starfighters would have a greater rate of survival against the Death Star's defenses than heavily armed capital ships, due to the slow rate of fire from the battle station's turbolaser batteries and their inadequacy at tracking fast-moving targets.

The rebel squadrons closed in on the Death Star. As Red Squadron targeted the Imperial guns, surface defenses near the target trench went up in flames. Gold Squadron was cleared for their approach. Although the massive Death Star carried thousands of TIE fighters, an overconfident Grand Moff Tarkin ignored the warnings of his aides and refused to issue a launch order.

Disagreeing, Darth Vader scrambled a single squadron of TIEs on his own authority. The TIEs launched into space and honed in on the rebel starfighters, forcing Red Squadron to abandon its strafing runs and engage the enemy in one-on-one dogfights.

With the X-wings occupied handling the TIEs, Gold Squadron set up for its bombing run. Their target, a two-meter-wide exhaust port, lay at the far end of a long surface trench. The rebel attack plan called for the lead ship and its two escorts to make an extended approach down the trench, giving the targeting computer enough data to calculate the precise speed and distance needed to make an optimal torpedo shot.

Only Darth Vader appeared to recognize the danger implied by Gold Squadron's actions. With two Black Squadron TIE pilots accompanying him, Vader peeled away from the dogfighting, and with his customized starfighter, the prototype TIE Advanced x1, he went after the Y-wing bombers.

Vader and his wingmen dropped into the trench directly behind the tightly clustered trio of Y-wings. Taking measured, deliberate aim, Vader destroyed all three rebel ships before they could launch a torpedo.

The rest of Gold Squadron had suffered its own losses, requiring the X-wings to take over the trench run. This time Red Leader took point, and he ordered his two escorts to hang back. Gold Squadron had flown

too close, making them easy targets. But with enough distance the lead ship would be guarded against attack from the rear—even if it meant putting the trailing escorts at risk.

The tactic nearly succeeded. Vader destroyed Red Leader's escorts, but by the time he had made up the distance that separated them from their commander, Red Leader had already fired his torpedoes. Unfortunately the shot missed, striking wide, left of the exhaust port. Before Red Leader could swing around for another run, Vader took aim and shot him down.

The rebel fleet had greatly diminished in number. Only a few starfighters remained. Luke Skywalker took point in his X-wing for the third-run attempt. By this time, the Death Star had completed its orbit of the gas giant and now had a clear shot at the jungle moon and the rebel base. The Death Star's gunners powered up the superlaser and waited for the command to fire.

> "NEVER AGAIN WOULD THE EMPIRE FACE THE ALLIANCE WITHOUT EXPLOITING ITS NUMERICAL SUPERIORITY."

With Red 2 and Red 3 as his escorts, Skywalker dropped into the trench. The trio followed Red Leader's example by maintaining a sizable gap between the lead ship and its wingmen, but this time all three ships boosted their speed to maximum. Skywalker hoped to leave Vader's TIEs in the dust.

Just as before, Darth Vader neutralized both rebel escorts—damaging one and destroying the other. He rapidly closed the gap on Skywalker's ship, but an unexpected burst of laser fire threw his own wingmen into chaos. Han Solo's *Millennium Falcon* had arrived, blasting one TIE and sending the other into a collision with Vader's own craft.

Skywalker launched his torpedoes. The warheads hit the exhaust port opening and rocketed down the magnetic shaft, striking the station's hypermatter reactor. As the surviving rebel starships flew out of range, the Death Star exploded behind them.

AFTERMATH

The Rebel Alliance's one-in-a-million victory stunned the galaxy. Seemingly overnight, the Rebellion had become a force to be reckoned with. Given the battle's outcome, and in light of the alarming news that the Emperor had dissolved the Imperial Senate, many worlds made clandestine overtures to the Alliance to provide funding, war matériel, and intelligence to aid them in their fight.

For the Empire, the Battle of Yavin was an utter disaster. However, the Imperial propaganda machine soon took control, burying and twisting the facts. The centrally run newsnets omitted any mention of the battle while using the event to dial up their anti-Rebellion rhetoric.

If the Imperial loss could be traced to any single cause, it was overconfidence. Grand Moff Tarkin had assumed that his Death Star did not require a naval escort. He had launched no TIEs in the battle station's defense, and Vader had launched only a single squadron. Almost all the blame for the debacle fell on Tarkin, who was no longer around to defend himself in any case.

Never again would the Empire face the Alliance without exploiting its numerical superiority. The Imperial Navy and Imperial Army entered a state of high alert. The next time the Empire faced the Rebel Alliance in combat, it would employ overwhelming force.

GRAND MOFF WILHUFF TARKIN

As an Imperial territorial governor, Tarkin enjoyed almost unlimited influence throughout the Empire's fringe territories. With the Death Star under his command, Tarkin arguably held more power than the Emperor himself.

COMBATANTS

1 **TIE FIGHTER PILOTS:** TIE pilots were graduates of the Imperial Academy, trained to fly effectively in large squadrons and flight groups. Pilots wore sealed flight suits with integrated air supplies in case they needed to eject into the vacuum of space.

2 **GOLD SQUADRON PILOTS:** The rebel pilots of Gold Squadron, originally commanded by Jan Dodonna, were all volunteers and came from a variety of backgrounds and homeworlds. Most were older pilots who had logged substantial flight time in the BTL Y-wing starfighter.

3 **RED SQUADRON PILOTS:** The pilots of Red Squadron were recruited for their skill in one-on-one dogfighting against Imperial TIE fighters. Prior to Yavin, most Red Squadron pilots were known for hit-and-fade raids against the Empire's supply convoys.

4 **DEATH STAR GUNNERS:** More than 15,000 turbolaser batteries studded the surface of the Death Star, each operated by a crew of gunners. Tracking the fast-moving rebel starfighters proved difficult for the gunners, who had been trained to fight enemy capital ships.

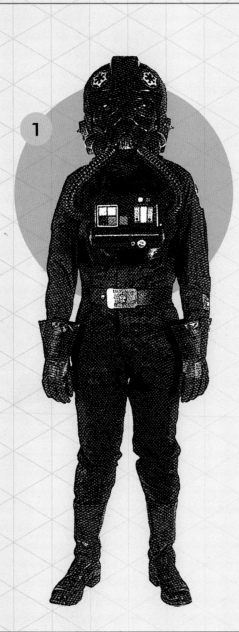

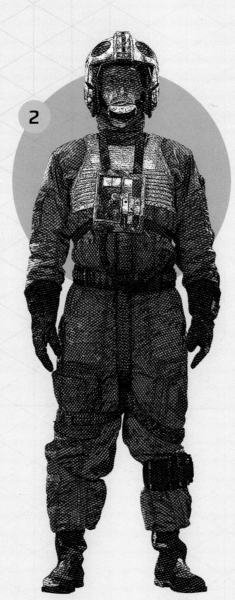

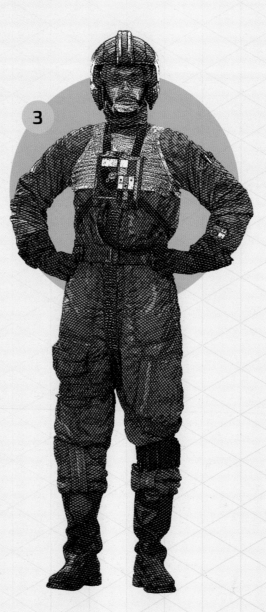

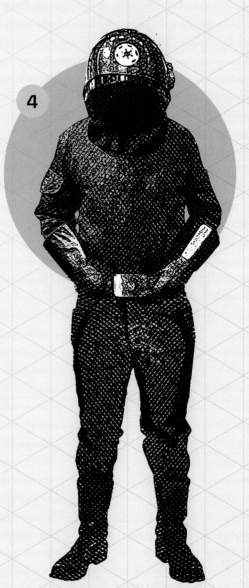

Wedge Antilles

YAVIN

I survived the Battle of Yavin, and for a long time, a part of me wished I hadn't. I know it's not a logical reaction, and I know because that's what everyone kept telling me at the time. But I'm not a droid. That's how I felt.

The attack on the Death Star was a suicide mission. We pilots are a superstitious bunch so no one was going to say it out loud. But while we were suiting up, I overheard Han Solo use those exact words. I wanted to slug him.

I had X-wing combat experience—more than Biggs, and definitely more than Luke—but I'd never gone up against anything like the Death Star. Just the way that distant gray orb turned into a vast gray horizon, and then became a three-dimensional landscape of machine-cut mountains and canyons . . . my brain kept readjusting, trying to make sense of its scale. It was disorienting. When the TIEs showed up it was almost a relief. I knew how to fight those.

Luke, Biggs, and I were in the same flight for the trench run. We were probably the trio with the least collective experience, and compared to them I was the veteran. It was up to me and Biggs to keep Luke safe until he could make the torpedo shot. We kept him in sight as we trailed his X-wing down the trench. At the speed we were going, we were really hoping that no TIEs would be able to close in on us from the rear.

But our pursuers weren't just any TIEs. When a laser blast from one of them melted my micromaneuvering controls, I was done. I couldn't continue the run. I had to get out of the trench. If I had stayed, I would have fishtailed into Biggs and taken us both out.

I apologized over the comm and pulled out of the trench. For just a moment I felt my fear turn into relief. That's the moment I always think about. That's the moment that hardened into guilt.

I know there wasn't any other way it could have gone down. But I owe Biggs Darklighter a debt, and it's one that I can't repay in this lifetime.

Red Leader
Garven Dreis

Garven Dreis, called "Dave" by his friends, served the Rebel Alliance as an X-wing ace and squadron leader.

During the Clone Wars, Dreis flew for the Rarefied Air Cavalry on his homeworld of Virujansi. After joining the Rebellion, he commanded Red Squadron to destroy the shield gate during the Battle of Scarif. An advocate of the versatile T-65 X-wing fighter as the backbone of the Rebel Alliance Starfighter Corps, Dreis encouraged the Alliance Starfighter Command to shift its squadron composition to emphasize the X-wing. In Garven's eyes, the X-wing's simplified control scheme would be easy for frontier bush pilots to master, ultimately aiding in recruitment and bringing more pilots into the Alliance's ranks.

During the Battle of Yavin, Garven Dreis led the X-wings of Red Squadron and shared command with Jon "Dutch" Vander of Gold Squadron. When the Y-wing bombers were eliminated in their trench run, Dreis made the call for the X-wings to make the run. He led the first X-wing run on the Death Star's trench, but his computer-assisted shot missed the target and exploded feebly against the battle station's hull. He died moments later, shot down by Darth Vader.

TOOLS OF WAR

1 **X-WING:** The T-65 X-wing was a well-balanced rebel starfighter that combined attack power, agility, and robust energy shields. It had two proton torpedo launchers mounted on its fuselage and four laser cannons, one mounted on each of its wings.

2 **Y-WING:** An aging bomber in service since the Clone Wars, the Koensayr BTL Y-wing starfighter was a slower, heavier craft not designed for dogfighting. In addition to its bomb payload, the Y-wing was armed with laser cannons and a swiveling ion cannon. The Alliance stole this particular squadron from Reklam Station.

3 **TIE FIGHTER:** The Empire's primary attack starfighter, the TIE/LN starfighter from Sienar Fleet Systems was named for the twin ion engines that propelled it at impressive speeds while emitting a distinctive scream. TIEs were unshielded and could be destroyed with a single hit.

4 **TIE ADVANCED X1:** This prototype for a shielded, hyperdrive-equipped TIE was flown exclusively by Lord Darth Vader. The TIE Advanced x1 greatly outclassed the standard TIE on speed and maneuverability.

5 ***MILLENNIUM FALCON:*** The YT-1300 Corellian freighter operated by Han Solo was a heavily modified cargo ship built for smuggling and blockade running. Its deflector shields were military grade, and it was armed with quad laser turrets on its dorsal and ventral hulls.

6 **TURBOLASER BATTERY:** Heavy turbolaser batteries were operated by gunner crews and were typically mounted on rotating turrets that maximized their effectiveness against larger, slower-moving targets. However, they could not turn quickly enough to track fast-moving starfighters.

7 **PROTON TORPEDO:** The energized, proton-scattering warheads delivered by proton torpedoes could puncture starship hulls and trigger overloads in power reactors. Maneuverability thrusters enabled proton torpedoes to make sharp turns while in flight.

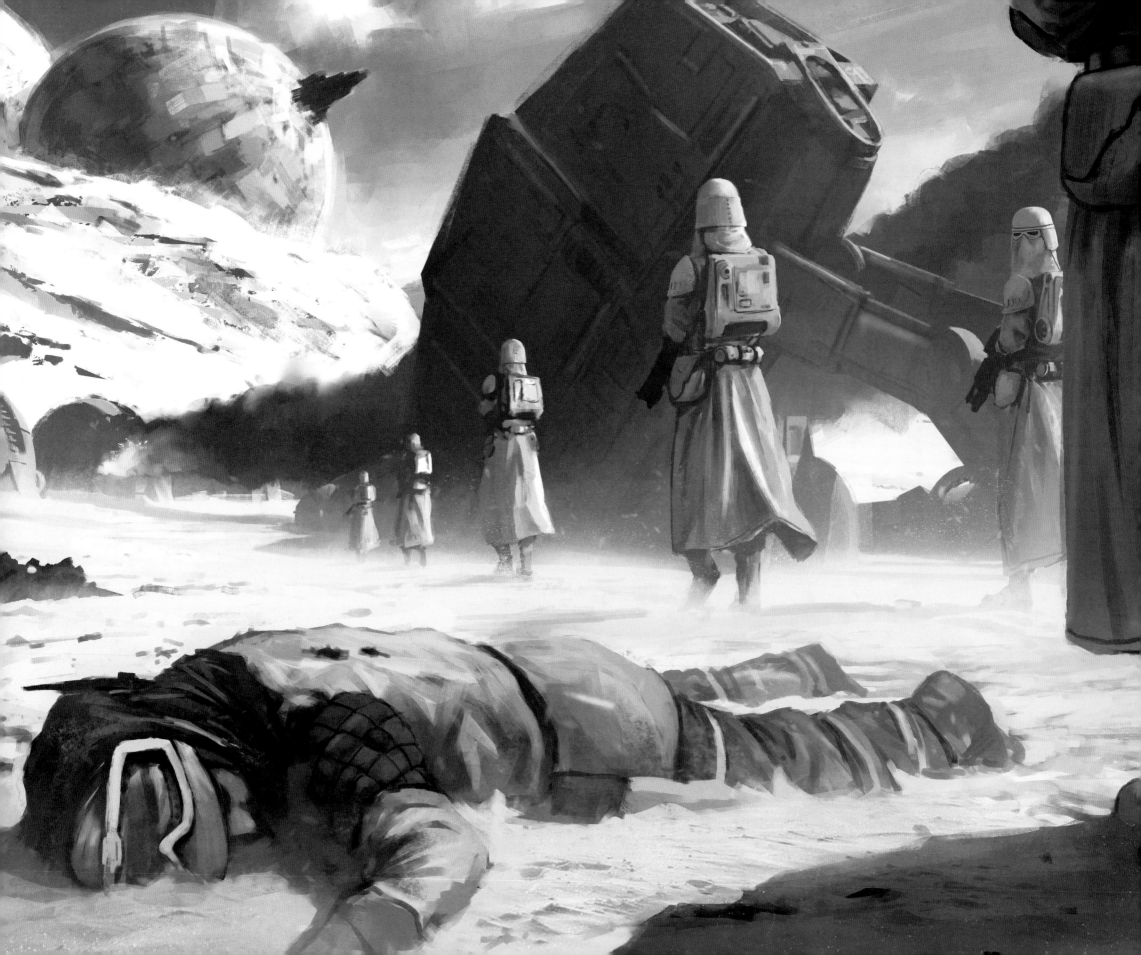

BATTLE OF HOTH

- GROUND -

The Rebel Alliance evacuated Yavin, knowing the Empire would be back for blood. It relocated its new command headquarters to the uninhabited ice planet of Hoth. Alliance high command hoped that Hoth's frozen inhospitality, its crowded asteroid field, and its sketchy history as a smugglers' bolt-hole would provide plenty of cover from the Empire's hunters and probes.

The Alliance, however, underestimated just how badly the Empire wanted to achieve a victory against the Alliance after losing the Death Star. Only a single Imperial—Lord Darth Vader—was known to have survived Yavin, and he now headed up an anti-rebel crusade that bordered on fanaticism. Five Imperial Star Destroyers, led by Vader's Super Star Destroyer *Executor*, formed a mobile task force called the Death Squadron,

and the Dark Lord followed up on every rumor that might lead them to the rebel nest.

The Emperor had given Darth Vader and the Death Squadron nearly unlimited authority in their hunt. Imperial Intelligence sifted through endless data, identifying anomalies for follow-up. Thousands of probe droids investigated the most promising leads, while Vader remained convinced that the Force would send him a sign.

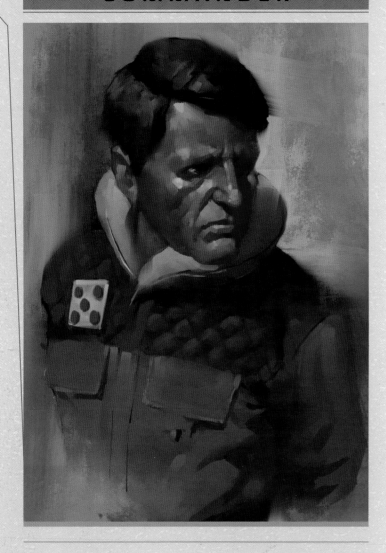

GENERAL CARLIST RIEEKAN

Rieekan served in the Republic military during the Clone Wars and later earned a post within the Royal House of Alderaan. Offworld when the Death Star destroyed Alderaan, Rieekan vowed to fight the Empire until his dying day.

PRELUDE TO BATTLE

A probe droid transmission led the Death Squadron to the sixth planet of the Hoth system. Vader knew that only a careful strike would prevent the rebels from scattering into hyperspace but left the execution of the attack to his naval commander, Admiral Kendal Ozzel. Had the Imperial fleet emerged from hyperspace at a distance and made a slow approach under the cover of the asteroid screen, the rebels may have been caught unaware. Ozzel, however, dropped out of hyperspace right on top of Hoth itself. Hyperwave alarms screamed and threw the rebels into high alert.

With the news that the rebels had activated a planetary shield to protect them from orbital bombardment, Vader executed Ozzel for incompetence. The new plan for eliminating the rebels on Hoth would focus on a ground attack with their forces landing outside the shield's perimeter and marching until they had reached the rebels' shield generator. The destruction of the shield generator would expose the Hoth battlefield and leave the rebels vulnerable to all the weapons in the Imperial arsenal.

> "THE ACES OF ROGUE SQUADRON WOULD PILOT THE SNOWSPEEDERS, KEEPING THEIR X-WINGS IN RESERVE TO ESCAPE THE PLANET."

TACTICAL ANALYSIS

When the Empire attacked, the Rebel Alliance had not been on Hoth long. The personnel assigned to work in Hoth's Echo Base suffered from the subzero temperatures as well as from the hostile native creatures. The arctic climate created countless equipment failures, and a horde of carnivorous predators would attack the base in search of warm bodies to eat.

Despite the effort put into setting up Echo Base, the instant the Empire arrived, all work ceased. The headquarters had already been lost. The Alliance could not defeat an Imperial force of that size in open combat.

General Rieekan's best-case scenario was an orderly retreat with minimal casualties. Echo Base scrambled to execute its evacuation protocols. The deflector shield snapped to life, buying time for the base's personnel to load up transports.

Rieekan deployed ground troops and T-47 light airspeeders to delay the Empire's advance. Rebel techs had recently modified the T-47s with cold-climate weatherproofing, making them the only option for airborne engagement. The aces of Rogue Squadron would pilot the snowspeeders, keeping their X-wings in reserve to escape the planet.

Imperial drop ships deposited an elite Imperial Army unit outside the edge of the rebel shield. This was General Veers's Blizzard Force, and its AT-AT walkers and AT-ST scout walkers carried battalions of Imperial snowtroopers.

The walkers of Blizzard Force advanced. Rebel ships weaved and fired at their enemies, but the heavy armor of the AT-ATs shrugged off their laser blasts. Commander Luke Skywalker suggested using a magnetic harpoon to hook the T-47's tow cable onto an AT-AT. The pilots could then loop the cable around the walker's legs to trip it up—a maneuver that required feather-touch flying. At least one walker went down in this fashion.

In orbit above Hoth, the Empire's Star Destroyers arrayed themselves into a blockade to prevent rebel transports from reaching their hyperspace jump point. As the

first transport broke the atmosphere, Echo Base fired a burst along the same vector from its Planet Defender ion cannon. The Empire didn't know the rebels possessed such a heavy piece of ordnance, and the Imperial blockade had done nothing to prepare for it. The ion blast struck the Star Destroyer *Tyrant* and scrambled its shipboard electronics. The rebel transport leapt safely to hyperspace, with more following in its wake.

Down on the snowy plains, the rebels sought victory through ingenuity. Skywalker took down a second AT-AT by planting a detonator in its belly; unfortunately scattered wins such as these weren't enough to turn back the relentless march of the Imperial line. Rebel casualties mounted as the AT-ATs fired their chin guns at the trench-huddled soldiers. The commander of the Echo Base defensive line ordered a retreat.

General Veers, commanding the lead AT-AT, reached firing range and aimed his walker's cannons at the shield generator. A fireball signaled the end of the planetary shield. A host of Imperial landing ships descended on Echo Base, with Darth Vader and a snowtrooper legion leading the way.

The rebels defended Echo Base corridor by corridor, knowing it was their last chance to slow the Imperial raiders and allow enough time for the last transports to blast out of the hangar. The Empire, however, had already begun its orbital bombardment. Darth Vader's vanguard force, eager to seize rebel VIPs before they could flee, stormed the tunnels despite the blasts raining down from the Star Destroyers overhead.

Turbolaser impacts struck the snow-covered surface, rocking Echo Base and causing the partial collapse of its carved-ice corridors. One squad of snowtroopers opened a locked chamber that the rebels had used as a holding pen for savage Hoth wampas. The release of the predators caused a temporary burst of chaos.

The surviving snowspeeder pilots of Rogue Group made it to their X-wings on the south ridge. These X-wings were the last rebel vehicles to leave Hoth.

Although a few rebel transports made it to safety, many more came apart under the guns of the Empire's Star Destroyers. Worse, other transports found themselves immobilized in the grip of tractor beams. Imperial Intelligence took possession of these captives and shipped them off to classified sites for interrogation. Most were never heard from again.

> "THESE X-WINGS WERE THE LAST REBEL VEHICLES TO LEAVE HOTH."

AFTERMATH

The Battle of Hoth ended in defeat for the Rebel Alliance, yet it could have been far worse. Thanks to the Empire's tactical errors, the Rebellion lived on—bloodied but unbroken.

The Alliance found itself in a tenuous situation. It had lost thousands of lives and millions of credits in military equipment. It was once again on the run, with reduced numbers and dwindling support from financial backers.

Fate could tip the scales either way. By retreating and licking its wounds, the Rebellion could scale back its ambitions and once again become a mere nuisance in the Empire's side. Or it could put everything it had left into one massive strike, fighting a battle with such high stakes that the Rebel Alliance could strike a fatal blow to the entire Imperial system.

GENERAL MAXIMILIAN VEERS

A brilliant tactician, General Veers earned notice for his vocal and persistent advocacy for the increased use of AT-ATs in ground operations. Darth Vader respected Veers for his eerily calm demeanor under fire.

COMBATANTS

1 IMPERIAL SNOWTROOPERS: The Empire's specialized cold-weather assault snowtroopers wore insulated armor with face masks that provided them with heated air. Many carried heavy blaster rifles.

2 AT-AT DRIVERS: AT-AT drivers were members of the Imperial Army, not stormtroopers (despite the similarity in their armor). General Veers personally selected all AT-AT drivers serving within Blizzard Force.

3 ECHO BASE TROOPERS: The Rebel Alliance ground troopers assigned to Hoth received special training for combat in subzero conditions. Taking cover in trenches, they used blaster rifles and antivehicle turrets to delay the Empire's advance.

4 SNOWSPEEDER PILOTS: The X-wing aces of Rogue Group pulled double duty on Hoth by piloting modified T-47 light airspeeders against the Empire's walkers. Two pilots paired up in each craft, with one operating the rear-facing harpoon gun.

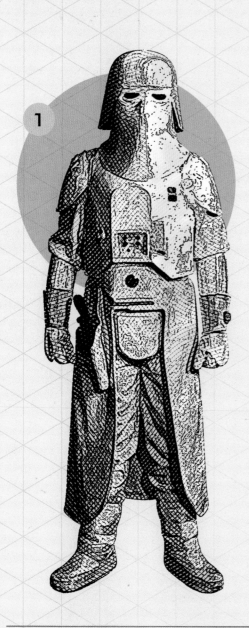
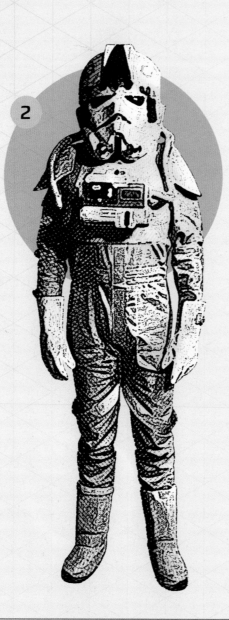
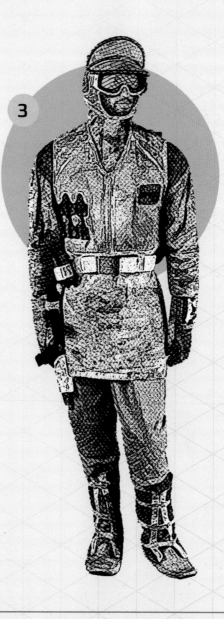
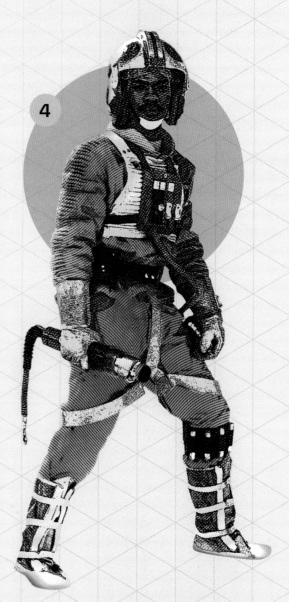

Chanda Bethari, Twilight Company

HOTH

Our guns weren't even scratching the AT-ATs. Not even our heavy guns like the DF-9s or the P-Towers. But I was with Parko and Barritz, and we were stationed on the far east side of the trench network. None of us could reach Captain Evon on the comm.

The big AT-ATs mostly advanced up the middle, so out on the edge of the battlefield we'd been pinned down by a little scout walker. I guess it wanted to keep us from flanking its big cousins.

The AT-ST kept spitting lasers at us, and we kept sinking lower and lower into the snow. Each blast took another bite out of the lip of the trench. But I knew we didn't have to be stuck there, not when the trenches all connected with each other. If I kept my head down and crawled fast to the left and another left, then after a couple minutes I'd be inside the trench that was a hundred meters ahead of our current position. And I'd get there just as the AT-ST would reach the same spot.

I arrived at the forward trench without being spotted and unstrapped my detonator pack. That was the closest I'd ever been to a walker. I could hear its joints groaning as it stepped in my direction. Every few seconds it took a potshot at Parko and Barritz, who'd stayed behind.

Once I had my pack in position I scuttled backward through the trench and unspooled the trigger wire. As soon as I'd reached a safe distance I was going to blow the pack and take out that AT-ST with it.

I don't know what happened or why the pack blew early. I woke up two days later, floating in a bacta tank on the *Redemption*. When Parko and Barritz came to see me, they told me that I blew off the walker's leg. After it went down, they pulled me out of there and got me to a transport.

Looks like I did the same thing to myself, but they tell me I'll get used to having a cybernetic limb.

Maybe mine wasn't the biggest victory. But I've heard a lot of stories since we left Hoth, and I know it could have been a lot worse.

TALES OF VALOR

Hobbie Klivian

Though Derek "Hobbie" Klivian gave his life on Hoth, his heroic death saved others by blunting the Empire's advance.

Klivian, a gifted pilot from childhood, honed his skills at the Empire's Skystrike Flight Academy and trained others in the arts of no-instrument navigation and asteroid running. Like many of his peers, Klivian sought a way to contact the growing Rebellion and use his skills against the Empire. A deep-cover rebel agent code-named Fulcrum provided the link that Klivian needed, and accompanied by his fellow pilot Wedge Antilles, he soon signed up with the Rebellion's Starfighter Corps as an X-wing jockey.

Klivian and Antilles distinguished themselves in early engagements, and both pilots became core members of the Rebellion's elite Rogue Squadron.

At Hoth, Klivian flew a snowspeeder and remained airborne long after most of his fellow pilots had been shot from the sky. After the Empire blew Echo Base's shield generator, the remaining rebels had little time left to escape.

When a hit crippled Klivian's snowspeeder, instead of ejecting from his craft, he flew it into the lead AT-AT, Blizzard One. The explosive impact decapitated the walker, saving dozens of fleeing rebels from its cannon fire.

T O O L S O F W A R

1 **AT-AT:** The All Terrain Armored Transport was the Empire's foremost ground assault vehicle. Armed with four laser cannons mounted to its head, the quadrupedal walker was nearly impervious to small-arms fire.

2 **SNOWSPEEDER:** The T-47 airspeeder was found on many worlds, but the Rebel Alliance modified its units to operate in the chilling temperatures of Hoth. Although armed with two laser cannons, the rebel snowspeeders found more success against the Empire's AT-ATs by using their harpoons and tow cables.

3 **ION CANNON:** The v-150 Planet Defender ion cannon that guarded Echo Base fired surface-to-orbit blasts designed to bypass the shields of enemy warships and scramble their onboard electronics.

4 **MAIN POWER GENERATOR:** Echo Base was protected from orbital bombardment thanks to an energy dome projected from a surface-mounted shield generator. Destroying the generator was the Empire's chief objective in the Battle of Hoth.

5 **REBEL TRANSPORT:** The Gallofree GR-75 medium transport was capable of carrying nearly twenty thousand metric tons of cargo or up to ninety passengers. These vessels formed the backbone of the Alliance's evacuation effort.

6 **MOUNTED TAUNTAUN:** When cold-weather modification to the T-47 airspeeders took longer than anticipated, the Rebel Alliance trained Hoth's native tauntauns to serve as mounts and pack animals.

7 **IMPERIAL PROBE DROID:** Arakyd Viper probe droids were dispatched to their planetary destinations inside disposable hyperspace pods. Built for stealth, they moved on antigravity repulsors and were equipped with self-destruct mechanisms.

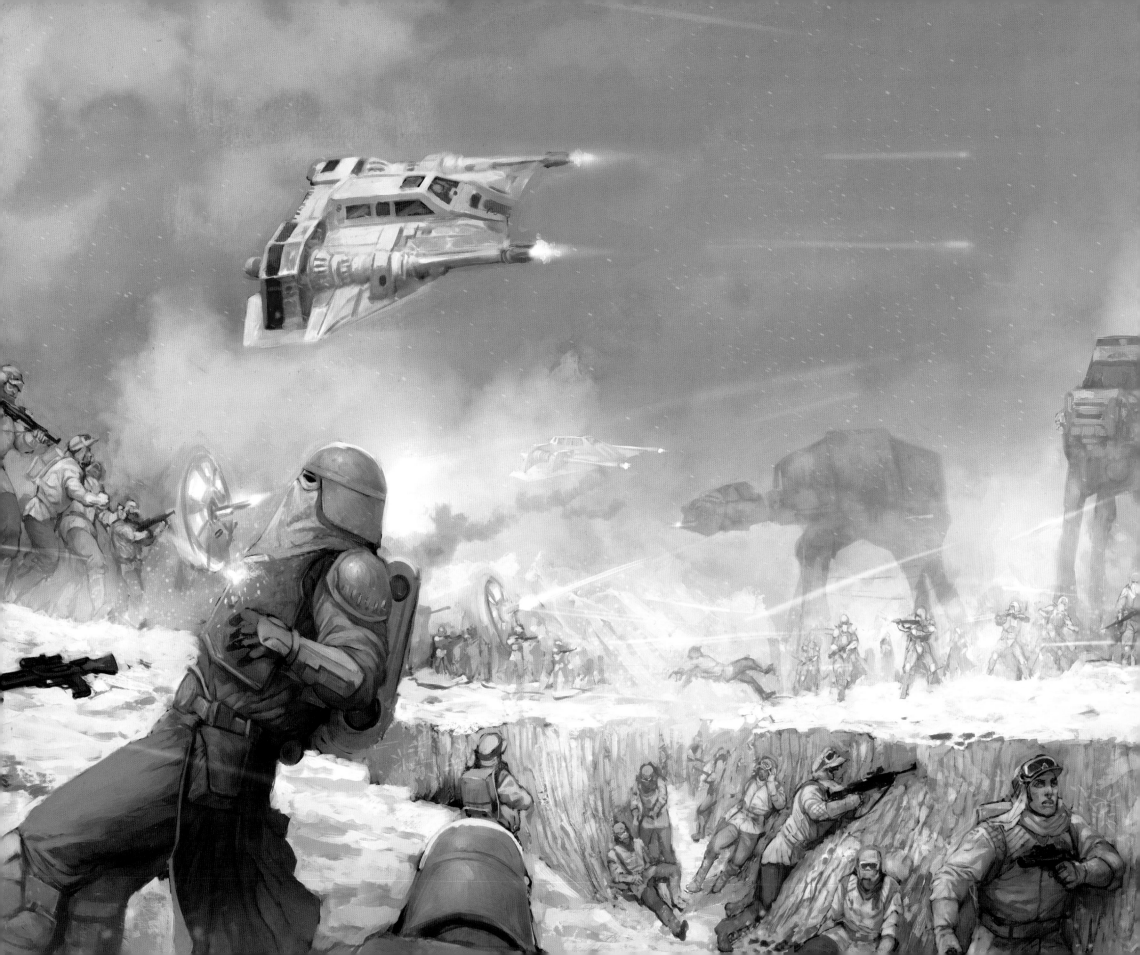

BATTLE OF HOTH

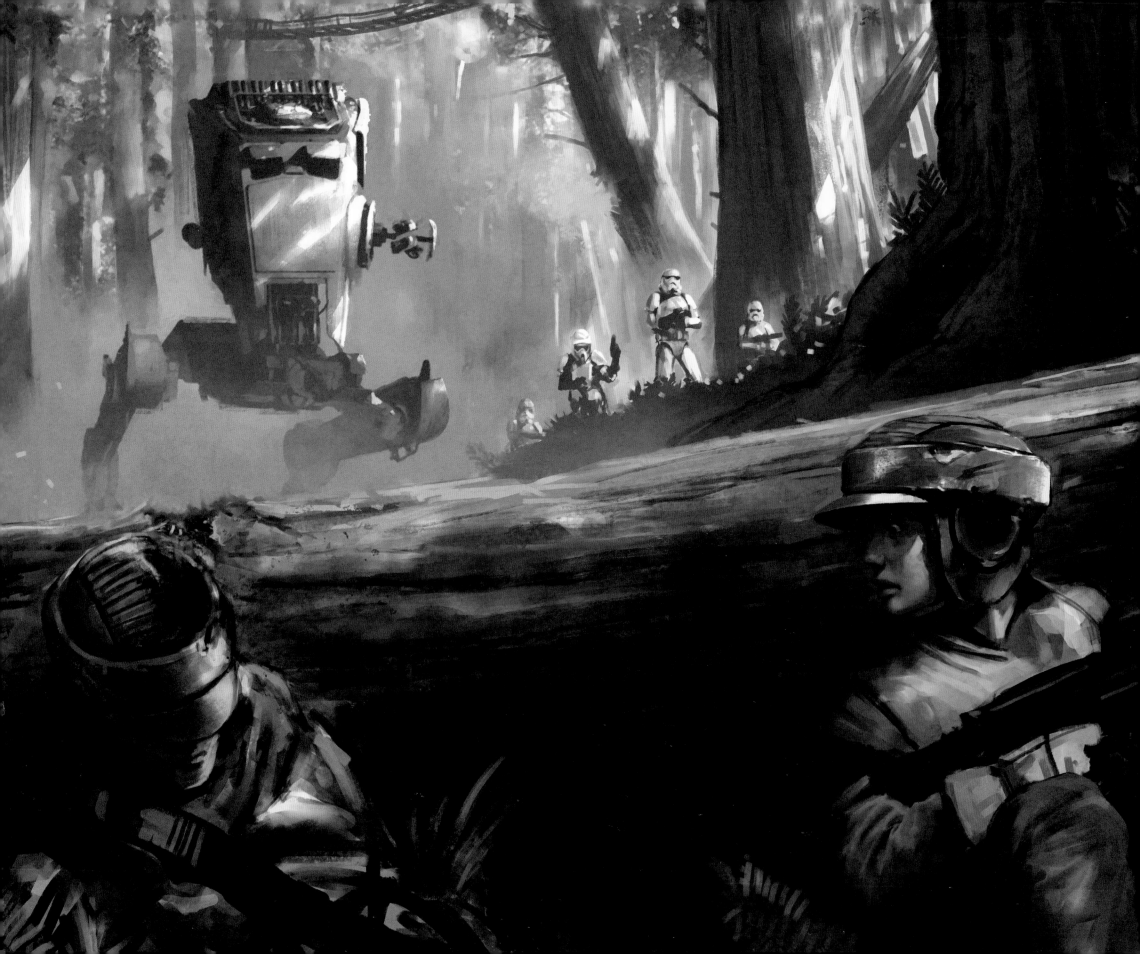

BATTLE OF ENDOR

- SPACE AND GROUND -

After the Battle of Hoth, Imperial commanders rightly concluded they had gained the upper hand on their rebel foes. The harried Alliance fleet remained on the move, constantly jumping from system to system rather than risking another fixed headquarters and a disastrous cornering. Mobility kept the Alliance's leaders safe from capture but hampered the Rebellion's ability to take the fight back to its enemy.

The Empire had a new reason for confidence, though it remained classified to all but the highest-ranking officials. Above a forest moon in the Endor system, the skeleton of a second Death Star had begun to take shape. Although still half-finished, the redesign of this Death Star eliminated the flaws that had doomed its predecessor, and until those fixes were implemented it would remain inside a protective energy shell.

The Rebel Alliance needed a break, and its tacticians believed they had stumbled upon a miracle when agents of the Bothan spynet obtained two critical pieces of intelligence. The first was the existence of the Death Star project and the coordinates of its construction site. The second was the news that Emperor Palpatine would be directly supervising the final stages of the battle station's completion. By destroying the former they would eliminate the latter, achieving an unprecedented military and political shake-up.

The prize was too tempting to resist, and all by design. Imperial Intelligence had leaked the information to bait a trap. Emperor Palpatine had foreseen the Alliance's destruction, and Endor would be the catalyst.

COMMANDER

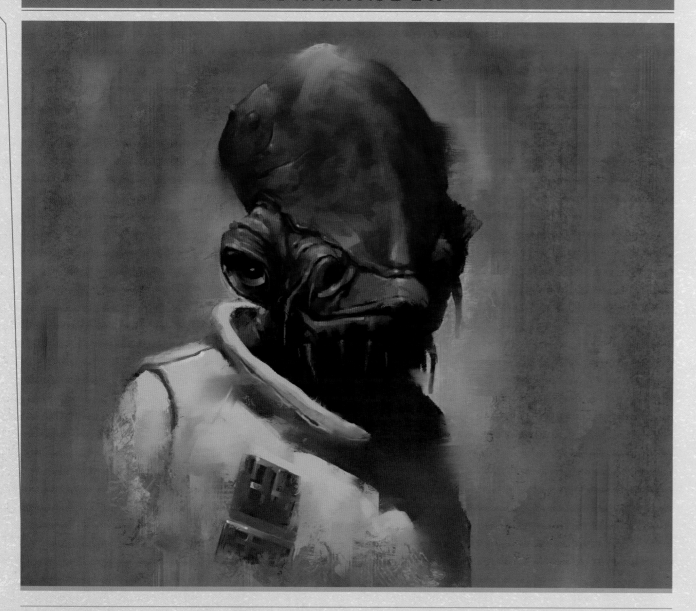

ADMIRAL ACKBAR

Ackbar was the supreme commander of the Alliance fleet and had won many naval victories against numerically superior Imperial armadas. His people, the Mon Cal, contributed most of the capital warships in the Alliance fleet, including the flagship *Home One*.

PRELUDE TO BATTLE

Some in the Rebel Alliance doubted the accuracy of the captured intelligence, but Alliance high command determined that the benefits outweighed the risks. The rebels threw everything into their all-or-nothing attack, striking quickly before the Empire could finish the battle station's weapons systems. Because no assault on the Death Star could occur with its shield in place, an advance force of commandos would land on the forest moon to disable the protective screen at its source.

"THE REBELS THREW EVERYTHING INTO THEIR ALL-OR-NOTHING ATTACK"

General Han Solo led the commandos. His captured Imperial shuttle slipped through a naval blockade to touch down near the Imperial garrison housing the shield generator. The countdown to the rebel attack had begun.

The Alliance fleet assembled near Sullust in preparation for the strike on Endor. Mon Cal cruisers would be the armada's heavy hitters, supplemented by frigates and corvettes and escorted by a host of Y-wing, X-wing, A-wing, and B-wing starfighters organized into Gold, Red, Green, and Gray flight groups, including the elite B-wing bombing crewers of Blade Squadron. General Lando Calrissian, piloting the *Millennium Falcon*, commanded the starfighter squadrons as Gold Leader.

If Solo's team could bring down the shield, ridding the galaxy of the second Death Star would be a possibility. In its half-finished state, small starships could fly directly into its inner core and drop torpedoes into its reactor.

The hypermatter explosion would destroy the Death Star. The rebels just had to get inside.

TACTICAL ANALYSIS

General Solo's groundside mission immediately ran into trouble. An Imperial patrol had spotted and nearly exposed them. It became imperative to eliminate the scout troopers, but the chase caused a separation between Solo's command crew and the rest of the rebel commandos.

The detour brought General Solo into contact with the Ewoks, the native species of the forest moon. They had gone undetected by the Empire during the construction of the shield generator, but the Ewoks had grown outraged by the casual destruction of their sacred trees. Chief Chirpa of the Ewoks assumed that the newcomers shared the same allegiance and decided to burn them alive in a ritual sacrifice.

Fortunately, General Solo's protocol droid, C-3PO—mistaken by the Ewoks for a golden god—translated for both sides. After some mistrust, the rebels and Ewoks formed an alliance and Ewok scouts showed Solo the best approach to the shield bunker.

Solo's crew linked back up with the rest of the rebel commandos and prepared to infiltrate the bunker and set explosive charges. The Empire chose that moment to spring its surprise. Stormtroopers, biker scouts, and AT-ST walkers had been deployed and appeared on the scene, overpowering Solo's squad and taking them prisoner.

The Ewoks burst from forest cover to aid their new allies, unleashing a hail of spears and arrows. The rebels escaped into the forest to continue the fight. But they had failed in their mission to take down the shield, and every second put them further behind schedule.

Still in hyperspace transit, the Alliance fleet had no way to react to the changing fortunes on the forest

Battle of Endor [SPACE]
COMMANDER

ADMIRAL FIRMUS PIETT

As captain of the Star Destroyer *Executor*, Piett received a promotion to admiral before the Battle of Hoth. Impressed with Piett's professionalism, the Dark Lord rewarded him with naval command over the Imperial fleet at Endor.

Battle of Endor [GROUND]
COMMANDER

GENERAL HAN SOLO

This former smuggler had only recently recovered from hibernation sickness following his rescue from carbonite captivity inside Jabba the Hutt's palace. Solo's skills as a pilot, fighter, and improviser were deemed invaluable to the success of ground operations.

Battle of Endor [GROUND]
COMMANDER

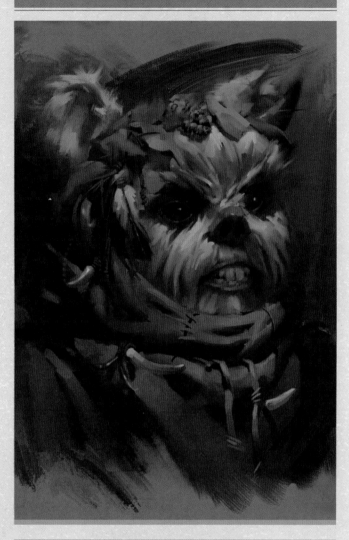

CHIEF CHIRPA

This wise Ewok had served as chieftain of Bright Tree Village for forty-two seasons prior to the intrusion of Imperial forces into Chirpa's territory. The behavior of the Empire caused Chirpa and his tribe to have a natural suspicion toward the rebel commandos.

moon. Admiral Ackbar knew that any disruption of the shield might only prove temporary, a fact that required his fleet to arrive at the Death Star within a precise time window. When Ackbar's armada dropped out of hyperspace, the Death Star remained shielded—unreachable and untouchable.

> ### "WHEN ACKBAR'S ARMADA DROPPED OUT OF HYPERSPACE, THE DEATH STAR REMAINED SHIELDED—UNREACHABLE AND UNTOUCHABLE."

Ackbar braced for an Imperial counterattack as Emperor Palpatine activated the second half of his trap. A massive Imperial fleet emerged from the far side of Endor, flanking the Alliance armada.

The Imperial fleet was led by the Super Star Destroyer *Executor* and consisted of thirty Star Destroyers and hundreds of TIE fighters and TIE interceptors. The Imperial starfighter swarm quickly closed the distance. X-wings and A-wings paired off with enemy TIEs as space lit up with explosions and laser flashes.

Admiral Ackbar kept his eye on the Star Destroyers, but they maintained their distance. Admiral Piett had received his orders from Emperor Palpatine himself, requiring all Imperial warships to hold position and cut off the Alliance's escape vector. The Emperor's rationale became clear when a lance of energy from the Death Star's superlaser vaporized the rebel cruiser *Liberty*.

The lethal perfection of the Emperor's snare was now chillingly clear. The Alliance fleet couldn't retreat, nor could it advance on the Death Star, leaving Admiral Ackbar with no defense against the superweapon.

With their backs against the wall, the Rebel Alliance exploited its catastrophic position through some desperate, quick-thinking solutions. Acting on a recommendation from General Calrissian, Ackbar brought his capital ships up against Admiral Piett's Star Destroyer line to discourage the Death Star from taking any more easy shots at isolated rebel targets. If the rebels caused enough damage, Admiral Piett might break formation, which would give the surviving rebel ships the chance to escape into hyperspace.

The Imperial fleet did not respond quickly enough to the Alliance's maneuvers. Admiral Piett feared the consequences if he countermanded the Emperor's orders, and a gradual breakdown in communications resulted in poorly placed Star Destroyers that squandered the advantage of overlapping fields of fire. A critical hit on the *Executor*'s bridge killed Piett, and his rudderless flagship drifted into a fiery collision with the Death Star.

Down on the forest moon, the Ewoks and the rebels found a rhythm of coordinated counterattack. Armored AT-STs exploded in crafty pitfalls while one AT-ST fell into rebel hands and turned its guns on the stormtroopers. With their morale renewed, the rebel commandos recaptured the bunker and planted fresh charges. The explosion shredded the shield projector dish.

In that instant, the shield protecting the Death Star vanished. Acting quickly, Lando Calrissian led a few of the surviving starfighters on a trip through the Death Star's superstructure. The *Millennium Falcon*'s missile strike overclocked the hypermatter cauldron, and the rebel ships retraced their paths as the chain reaction began to brew. The rebels reached clear skies as the Death Star exploded.

The remaining Imperial warships kept up the fight, but with no orders from the admiral or the Emperor, command fell to Admiral Sloane of the Star Destroyer *Vigilance*. She issued the order for a full retreat, and one by one the Imperial fleet ceded the battlefield until only the Rebel Alliance remained.

AFTERMATH

By lopping off the Empire's head and burning its greatest military asset, the rebels massively shifted the war in their favor. But the news of the Emperor's death didn't lead to an immediate Imperial implosion.

Some worlds celebrated, but others refused to entertain what they considered lies and delusions. High-ranking Imperial military commanders knew the truth of Palpatine's death, but many of them viewed his demise as a perfect opportunity to seize power for themselves.

A fragmented Empire was a weaker enemy than a unified one, but each fragment had jagged edges. The Alliance proceeded with caution. With Admiral Ackbar in command of the fleet, the Alliance advanced on loyalist Imperial territories in the Inner Rim and Mid Rim.

The war wasn't over yet, but for the first time in decades peace seemed like more than a promise.

> ## "A CRITICAL HIT ON THE *EXECUTOR*'S BRIDGE KILLED PIETT, AND HIS RUDDERLESS FLAGSHIP DRIFTED INTO A FIERY COLLISION WITH THE DEATH STAR."

MAJOR HEWEX

An officer in the Imperial Navy, Hewex commanded the naval detachment assigned to defend the bunker containing the deflector shield's power generator.

COMBATANTS

1 **TIE FIGHTER PILOTS:** Hundreds of TIE pilots flew at Endor, operating standard TIEs as well as variants, including TIE bombers and TIE interceptors. Their swarm attacks were designed to intimidate by showing off the extent of the Empire's resources.

2 **REBEL PILOTS:** The Rebel Alliance divided its Endor starfighter complement into four groups, roughly corresponding to the A-wing, B-wing, X-wing, and Y-wing classification sets. General Lando Calrissian commanded the rebel pilots.

3 **REBEL COMMANDOS:** Specialists at infiltration and sabotage, rebel commandos were skilled at improvisation and could operate behind enemy lines for weeks or months at a time.

4 **IMPERIAL SCOUT TROOPERS:** As members of the Stormtrooper Corps who trained for reconnaissance and skirmishing, scout troopers wore lightweight armor and piloted 74-Z repulsorlift speeder bikes.

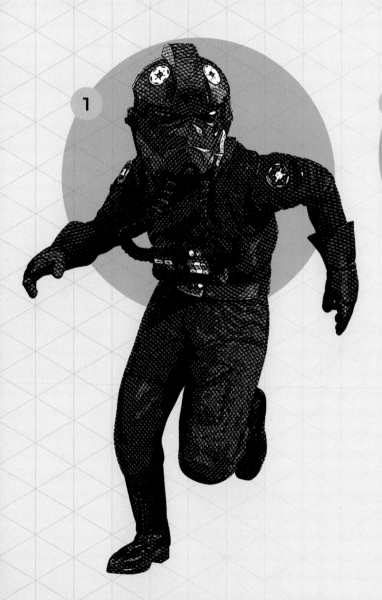

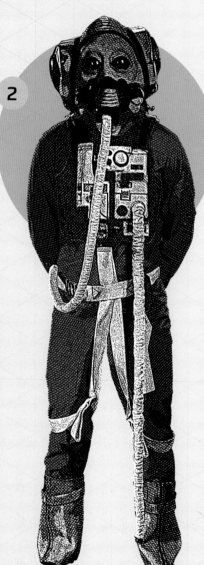

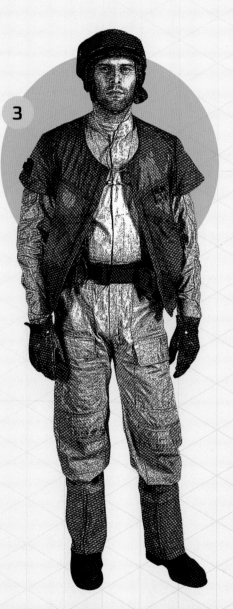

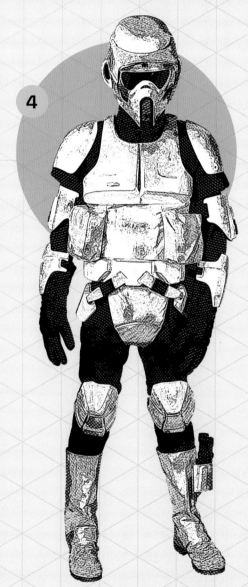

COMBATANTS

5 **EWOK WARRIORS:** Nearly all adult Ewoks were trained fighters, having honed their skills against Endor's megapredators. Ewok weapons included bows, slings, bolas, spears, and catapults.

6 **REBEL FLEET OFFICERS:** Many officers in the rebel fleet were members of the Mon Calamari species due to the preponderance of Mon Cal warships in the Alliance's attack line.

7 **IMPERIAL FLEET OFFICERS:** Discipline under fire and adherence to a rigid chain of command were hallmarks of Imperial fleet officers. Almost all officers were graduates of the Imperial Naval Academy.

Commander Arvel Crynyd

Commander Crynyd flew as Green Leader at the Battle of Endor, heading up the rebel A-wing group. His life ended with a grand sacrifice that sapped the Empire's naval strength at a critical moment.

Crynyd, a veteran pilot and instructor, had spent more time in an A-wing cockpit than anyone else in the Alliance Starfighter Corps. He praised the squat, wedge-shaped A-wing profile and maintained that skilled A-wing pilots could easily outfly their Imperial counterparts in TIE interceptors. Recognizing that the lightly shielded A-wings couldn't stand up to Imperial Star Destroyers, Crynyd pushed them into reconnaissance and escort missions where speed meant strength.

At Endor, Crynyd ordered Green Group to mix it up with the TIEs to thin out the enemy starfighter screen and take the pressure off the B-wing bombers. As the battle dragged on, Green Group lost more than two-thirds of its A-wing complement.

Outnumbered but vowing to make a difference, Crynyd directed Green Group's survivors to execute fast-and-close strafing runs across Star Destroyer superstructures. Zigzagging to avoid cannon blasts, the A-wings knocked out turbolaser batteries with paired concussion missiles and laser barrages.

As Crynyd passed over the bow of the Super Star Destroyer *Executor*, his A-wing took a mortal hit. With his systems failing, Crynyd forced his stricken craft into a path that intersected with the *Executor's* bridge. When Crynyd's A-wing hit, it exploded like a bomb—killing Admiral Piett and leaving the Imperial fleet without a leader.

Nien Nunb (translated from Sullustan)

ENDOR [SPACE]

Raise your glass to the smugglers! It's like I kept telling Lando, blockade running beats flight school every day. Maybe now Ackbar will start listening.

It's not like Lando and me were the only ex-smugglers in the fleet, but the *Millennium Falcon* was definitely the only real smuggling ship. And if you ask me, that was a big miss. Blame Ackbar or blame Mon Mothma, but ships like the *Falcon* have every right to be in the order of battle.

I mean the *Falcon* had military-grade everything: sublight engines, quad turrets, deflector shields—the works.

And my ship, the *Mellcrawler*? Probably even better, but don't tell Solo I said that.

The *Falcon* was just as maneuverable as those TIE interceptors. And at her size!

I feel good now, but I'll confess that I wanted to jump back into hyperspace the minute those Star Destroyers showed up. It's a habit. You can't help it when you have dealt with Imperial Customs for as long as I have. Lando reminded me that we were in this game for the whole pot, and we were in it together.

I didn't *really* get scared until Lando took us inside the Death Star, and that was only because I was in the copilot's seat. I know cavern-running—I'm from Sullust, for vape's sake! But Lando was flying way too hot and way too close. If it had been me on the stick, we wouldn't have lost the radar dish.

As soon as we made it to the reactor we took the shot and blew it up. Okay, Antilles helped. But that guy is no stranger to running sketchy cargo either!

So I'll say it one more time: to the smugglers!

Sergeant Kes Dameron

Kes Dameron served with the Pathfinders, an Alliance Special Forces unit handpicked by General Han Solo to lead the sabotage mission on the moon of Endor. Though the Rebel Alliance earned far more notoriety for its starfighter heroics than its planet-side operations, Dameron and his fellow Pathfinders liked it that way. Sergeant Dameron cultivated a talent for retrieval and sabotage, carrying few weapons so he could blend in among natives and get out fast if compromised. At Endor, Dameron was joined by Pathfinders specializing in demolitions and wilderness survival.

After the rebels arrived on site, General Solo and his companions parted ways with Sergeant Dameron's Pathfinders almost immediately. Over the next day and night, Dameron and his fellow commandos scouted the Imperial bunker on their own, amassing a wealth of information about hidden traps in the trees, including catapults, rope snares, camouflaged spikes, and swinging logs. Dameron warned the squad that they might have to fight an indigenous enemy and was relieved to learn that the Ewoks had become their allies.

When fighting broke out, Dameron directed stormtroopers into dead-end ambushes and led AT-STs down trap-filled paths. Once the Ewoks realized his intentions, Ewok warrior Kneesaa stayed with Dameron to coordinate more complicated tactical maneuvers, communicating with each other through gestures and verbal stresses.

Sergeant Dameron and Kneesaa skipped the Endor victory celebration, and toasted their success over a bottle of sunberry wine instead.

TOOLS OF WAR

1 **TIE INTERCEPTOR:** The dagger-winged TIE interceptor was a much faster and more maneuverable variant of the Empire's standard TIE fighter.

2 **STAR DESTROYER:** An unmistakable symbol of the Empire's authority, the triangular Imperial Star Destroyer was 1,600 meters in length and outfitted with turbolasers, ion cannons, and tractor beam projectors. It was surprisingly fast for a ship of its size.

3 **A-WING:** An agile, speedy interceptor, the Rebel Alliance A-wing had flight capabilities that rivaled or surpassed those of the Empire's TIE interceptor. The A-wing was armed with twin laser cannons and a concussion missile launcher.

4 **SUPER STAR DESTROYER:** The first ship of its class, the Super Star Destroyer *Executor* served as the Imperial flagship at Endor. At 19,000 meters from stem to stern, it packed unimaginable firepower into its blade-shaped frame.

TOOLS OF WAR

5 **B-WING:** The gyroscopic B-wing filled the role of rebel heavy bomber at the Battle of Endor. With a payload of proton torpedoes and multiple laser cannons and ion cannons, it could cripple most enemy warships.

6 **MON CAL CRUISER:** The Mon Calamari species manufactured most of the Rebel Alliance's heavy warships—including its flagship, *Home One*. MC ship variants averaged between 1,200 and 1,500 meters in length.

7 **NEBULON-B FRIGATE:** A midsize vessel often used in picket duty, the Neb-B was well armed with more than two dozen weapons emplacements. The Rebel Alliance outfitted several of its frigates to serve as mobile medical centers.

8 **AT-ST:** The bipedal All Terrain Scout Transport was a lightly armored walker often used for perimeter patrol. It was armed with a concussion missile pod and two chin-mounted laser cannons.

TOOLS OF WAR

9 **SPEEDER BIKE:** The Arakyd 74-Z speeder bike was capable of traveling at speeds up to five hundred kilometers per hour. It was equipped with a single, forward-facing blaster cannon.

10 **SHIELD GENERATOR:** The shield generator constructed in the Endor forest used a parabolic dish to beam an energy shield into orbit. The barrier completely protected the second Death Star from physical or energy-based attacks.

11 **EWOK TRAPS:** Fashioned from logs and ropes, the Ewoks' ingenious traps, cleverly camouflaged among the trees, proved remarkably effective at thinning Imperial numbers on the forest moon.

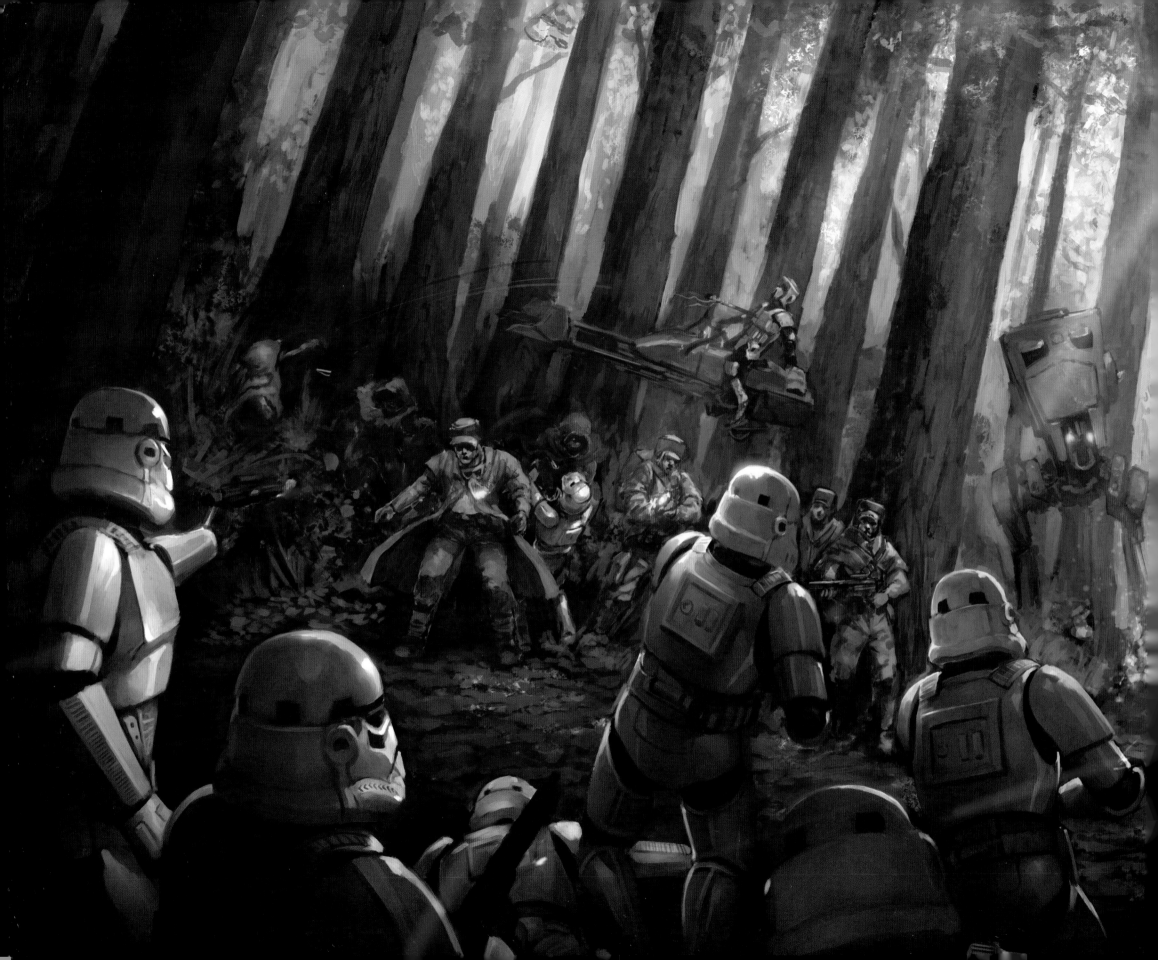

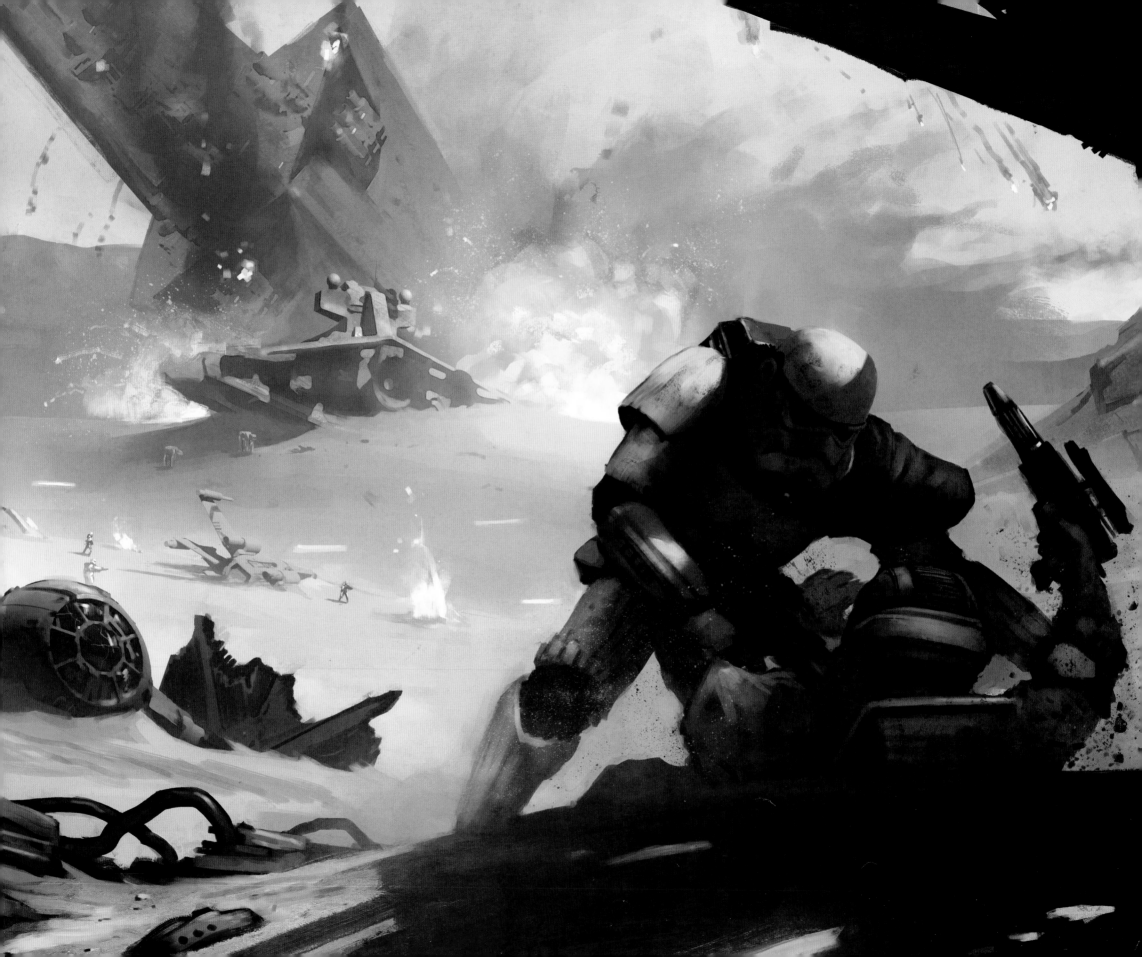

BATTLE OF JAKKU
- G R O U N D -

Despite the popular narrative, the Empire did not perish at Endor. It took a full year for its wounds to become fatal, with the final blow occurring at the Battle of Jakku.

During the intervening year, the Rebel Alliance rebranded itself as the New Republic and took on the unfamiliar task of galactic governance. The Empire, meanwhile, sought to reclaim its glory in fits and starts. On Imperially held Coruscant, Grand Vizier Mas Amedda issued feeble proclamations while the Empire's

power players made their own moves. On the Outer Rim world of Akiva, many of these players assembled as the "Imperial Future Council" until a New Republic raid forced them to scatter.

Imperial commander Gallius Rax united the Empire's strongest elements and struck a shocking blow against his enemy by sabotaging the Liberation Day peace talks on the New Republic's de facto capital of Chandrila. Bestowing upon himself the unprecedented title "Counselor to the Empire," Rax drew the

Imperial Navy to Jakku, a desert planet housing a secret Imperial research facility.

In orbit above Jakku, the Empire prepared for its biggest fight since Endor. The New Republic viewed the assemblage as a gift—an opportunity to clear the Imperial Navy from the battlefield in a single stroke—while the Empire remained stubbornly convinced it would deliver a shocking setback to the New Republic usurpers. From either view, it was clear the battle at Jakku would forever alter the galaxy's political order.

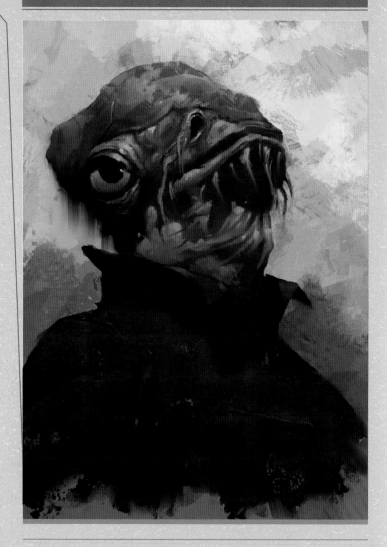

ADMIRAL ACKBAR

After leading the Alliance to victory at the Battle of Endor, Admiral Ackbar continued in his role as supreme fleet commander in the battles that followed. He hoped to end the war quickly and ensure a peaceable foundation for the New Republic.

PRELUDE TO BATTLE

Jakku held little material or strategic value. Sparsely populated and aggressively inhospitable, the planet was the site of an Imperial research lab in part because of its isolation. Gallius Rax believed that Jakku represented a critical step in executing one of the late Emperor's contingency plans. He advertised Jakku as a rallying point for the scattered Imperial factions.

The fight at Jakku would be immense. Grand Moff Randd, charged by Rax with defending the world against the New Republic's attackers, committed a hefty portion of the Imperial fleet to the task. He was convinced that the New Republic would either suffer devastating losses or withdraw in a panic when confronted with so much firepower. Either outcome would be a victory for Rax. The New Republic's defeat would leave the Empire in control of Jakku's sector, positioning the Western Reaches as part of the Imperial sphere of influence and giving Rax the time he needed to excavate any of Palpatine's forgotten assets.

TACTICAL ANALYSIS

Mere days after the Battle of Endor's one-year anniversary, the Empire and New Republic faced each other above sun-scorched Jakku. The New Republic's objective was to destroy or capture as many Imperial capital ships as possible and seize the assets in the research facility below. The Empire sought an overwhelming naval victory, one that would establish a new Imperial home sector and inspire a fresh wave of territorial gains.

Early reports of an Imperial fleet gathering at Jakku were leaked by Gallius Rax, knowing the news would reach New Republic Intelligence. Despite the possibility of a trap and the debacle that was the Liberation Day attack, most New Republic analysts truly believed the Empire to be on its last legs. A decisive victory would open up the possibility for a cease-fire, or even a permanent peace treaty.

Though Imperial territory had shrunk since Endor, the Empire still held many major shipyards. General Carlist Rieekan, frustrated by the New Republic's inability to match the Empire in warship production, saw an opportunity to capture intact Star Destroyers at Jakku. Because many officers in the New Republic fleet had graduated from the Imperial Naval Academy, Rieekan formed squads of ex-Imperials and charged them with boarding enemy vessels. By disabling hyperdrives and weapons systems, saboteurs could take entire Star Destroyers out of the fight.

The New Republic fleet emerged from hyperspace at Jakku, commanded by Admiral Ackbar aboard the MC80 cruiser *Home One* and Commodore Kyrsta Agate aboard the *Starhawk*-class battleship *Concord*.

The Imperial fleet they faced, however, was formidable. Anchored by the Super Star Destroyer *Ravager*, the Empire's armada took full advantage of its strategic deployment around the hyperspace exit point. Space lit up with strobing turbolaser flashes as the Imperial warships opened up all guns.

Frantically fanning out to secure better positions, the New Republic warships fired back and launched all starfighters from their hangar bays. Though the New Republic's MC80 star cruisers were arguably outclassed by the Imperial Star Destroyers, Admiral Ackbar believed the superior firepower and shielding of his B-wing squadrons would provide a critical advantage. While Blade Squadron battled the enemy capital ships, the X-wings and A-wings of Phantom and Phoenix Squadrons pummeled Jakku's air-to-space turbolaser batteries.

The Empire had the early edge, but as the battle wore on and Star Destroyers took damage, the divisions in

Grand Moff Randd's fleet became apparent. The Imperial commanders had little ideological loyalty. Individual battle groups began falling back, claiming they had taken too many losses and letting rival battle groups take their turns under the New Republic's cannons.

Stricken Imperial warships began to slip from orbit. Pieces of their superstructures burned away as they were pulled down by Jakku's gravity and landed in the desert sand. Thanks to emergency repulsorlifts, many vessels remained relatively intact, despite onboard fires and fuel leaks. Legions of stormtroopers and even a few AT-ATs disembarked and regrouped around the Imperial research facility.

The New Republic followed the Empire down to Jakku, using U-wings to drop commandos amid the burning wreckage. Meter by meter, the New Republic soldiers fought their way forward, while TIE fighters and A-wings screamed across the skies, and the ground shook from the impact of starship wrecks. The desperate Imperial troopers, now employing the guerilla tactics of their enemy, hampered their progress.

Grand Moff Randd drew blood when a stricken Star Destroyer plowed into the New Republic vessel *Amity*, with the debris from the collision critically wounding the *Concord*. Commodore Agate remained at the helm of the *Concord* long enough to lock its tractor beams onto the *Ravager*, and both warships slid downward to Jakku's surface. The *Ravager*'s impact smashed the core of the Empire's surface defenses.

General Rieekan's boarding squads had mixed success in capturing intact Imperial vessels. Aboard the Star Destroyer *Inflictor*, Commander Thane Kyrell's team could not prevent the ship's commander from scuttling her vessel by crashing it into the surface of Jakku. Though he had failed at his primary objective, Kyrell secured a partial victory by taking the *Inflictor*'s captain into custody as a prisoner of war.

AFTERMATH

The Battle of Jakku dragged on for weeks as Imperial holdouts refused to surrender, but the New Republic's victory had already been logged.

Grand Vizier Mas Amedda agreed to a cease-fire and signed the Imperial Instruments of Surrender during a ceremony on Chandrila. This act brought a formal end to hostilities and stipulated the Empire's immediate dissolution. Under the terms of the Galactic Concordance, Imperial officers were categorized as war criminals and the New Republic took command of Coruscant. Amedda remained on as a figurehead ruler, ignored by New Republic officials and utterly despised by the few remaining Imperial loyalists.

The war was over, but not every Imperial faction could be accounted for. The nature of Gallius Rax's "contingency plan" could not be discerned, though evidence remained of his fanatical fixation on ancient Sith artifacts and the unmapped blankness of the Unknown Regions. New Republic agents dug for more information on Rax—as well as the location of Rax's former associate Grand Admiral Rae Sloane—but came up empty.

Though the galaxy's attention shifted from Jakku, the detritus from the battle remained. Nicknamed the "Graveyard of Giants," the stretch of desert housing the largest wrecks attracted scavengers. At the tiny port of Niima Outpost, Jakku built a new economy centered on refurbishing and reselling starship tech.

> ## "THE RAVAGER'S IMPACT SMASHED THE CORE OF THE EMPIRE'S SURFACE DEFENSES."

GRAND MOFF RANDD

The former ruler of the Empire's Outer Rim, Grand Moff Randd revered Emperor Palpatine and vowed revenge on the New Republic for his death. A member of Gallius Rax's inner council, Randd united the major Imperial fleet elements for a strike against their enemy.

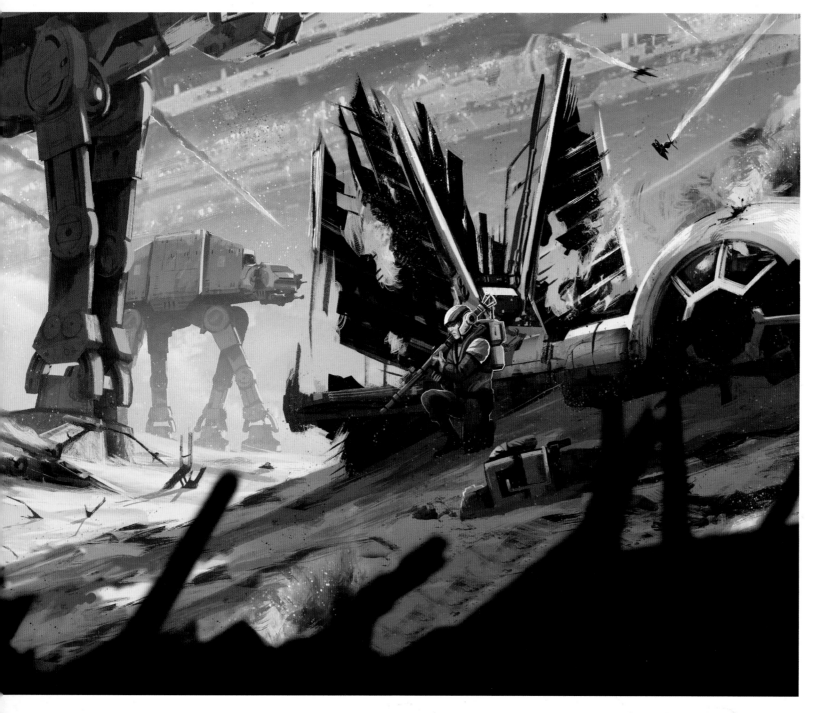

Odavia Anaru

As an A-wing pilot assigned to General Rieekan's ship *Striking Distance*, Anaru was among the starfighter escorts that accompanied the New Republic transports down to the surface of Jakku and protected them while they off-loaded squads of commandos. Anaru circled above the battlefield, strafing Imperial positions with her A-wing's laser cannons and shooting down three TIE fighters sent to oppose her.

Knocked out of the sky by a surface-to-air missile, Anaru ditched her mangled A-wing in the sand and sprinted for cover despite an injured leg. Her crash site had stranded her far from the New Republic commandos, forcing her to fight off Imperial stormtroopers with nothing but her standard-issue blaster pistol.

When the Empire deployed AT-ATs to protect its research facility, the walkers turned their cannons on the entrenched New Republic commandos. Anaru, retreating to better cover, took a rocket launcher from a fallen trooper. Bracing the heavy weapon against a broken hull fragment, she took aim at the lead AT-AT, *Hellhound Two*, and fired.

Stormtroopers rushed her position, but Anaru didn't move, carefully firing all six rockets at the AT-AT's weak points. *Hellhound Two* crumbled, though Odavia Anaru was not alive to see it. Anaru was posthumously awarded the Medal of Valor.

COMBATANTS

1 TIE FIGHTER PILOTS: TIE pilots in Imperial service as of the Battle of Jakku were an uneven mix of battle-tested veterans and raw recruits lacking discipline and adequate training.

2 NEW REPUBLIC PILOTS: The X-wing, A-wing, and B-wing pilots of the former Rebel Alliance used their fast-moving and well-armed starships to fly rings around their harried TIE counterparts and often took part in ground-based strafing missions.

3 IMPERIAL FLEET OFFICERS: The Empire's weakened state didn't rattle many of the Imperial officers, who still viewed Star Destroyers as the ultimate expression of naval dominance. They believed they could easily defeat the New Republic in a straight fight.

4 NEW REPUBLIC FLEET OFFICERS: Filled with confidence after a string of victories, the New Republic's naval commanders sought to press their advantage at Jakku. Destroying a significant portion of the Empire's Star Destroyer line would break what remained of their enemy's naval strength.

TOOLS OF WAR

1 STAR DESTROYER: Dozens of *Imperial I*-class Star Destroyers formed the backbone of the Imperial battle line at Jakku. Grand Moff Randd commanded the fleet from the bridge of the *Acidity*, his personal Star Destroyer and flagship.

2 TIE FIGHTER: The Empire manufactured many more TIE/ln starfighters after the defeat at Endor, despite a lack of qualified pilots to fly them. Poorly trained pilots were often paired with veterans, leading to ineffective and undisciplined TIE formations.

3 CR90 CORVETTE: This popular model of cruiser from Corellian Engineering Corporation was also known as the blockade runner due to its impressive sublight speeds. It measured 127 meters and was armed with dual turbolaser turrets.

4 A-WING: After Endor, the New Republic boosted its production of A-wings to counter the Empire's increasing reliance on TIE interceptors. The A-wing's concussion missiles could also be used against larger warships.

5 AT-AT: On the surface of Jakku, All Terrain Armored Transports from the Star Destroyer *Interrogator* staged a last-ditch defense of the Imperial research facility. These AT-ATs, belonging to the Hellhound attack force, had participated in dozens of battles since Endor.

6 MC80 STAR CRUISER: None of the New Republic's Mon Cal star cruisers were completely alike, although they bore similar rounded, organic-looking profiles. These Mon Cal cruisers, including General Rieekan's ship, *Striking Distance*, were armed with turbolasers, ion cannons, and tractor beam projectors.

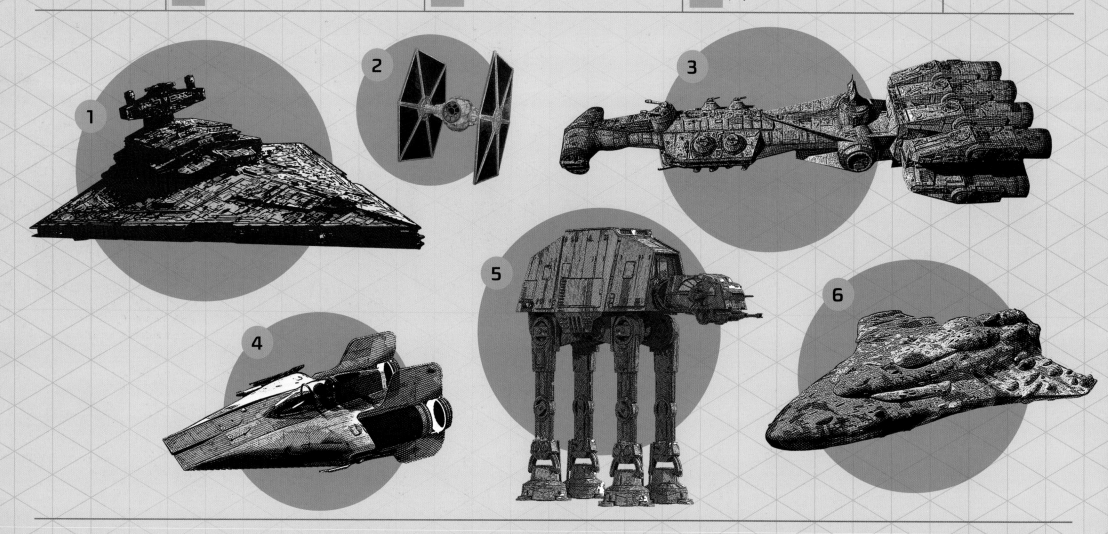

Musmuris Reetgeet

JAKKU

General Rieekan gave us our orders: infiltrate and capture an Imperial Interdictor. Our target would be the Immobilizer 418 cruiser *Glaciate*—six hundred meters long, armed with twenty laser cannons.

And then there's me, a Ranat! No, I hadn't served on an Imperial ship before, are you kidding? Just look at me. But I had the perfect set of skills for this mission, and I'd been itching to use them ever since I'd signed up with the rebels. Until Jakku, no one had ever given me a chance.

You'd think me being a Ranat wouldn't matter so much in the New Republic, but you'd be wrong. Maybe everybody had had a bad experience with some other Ranat? Maybe

everybody was a little too quick to judge my small eyes and large incisors? Those eyes can see into the infrared. And those teeth can gnaw through a duracrete plate.

Everyone else in my squad was human, all of them ex-Imperials who'd served aboard an Interdictor. Inside a captured Imperial assault shuttle, we made a beeline for the *Glaciate*, praying for protection from TIEs and turbolasers. When we got there we made a hole in the hull just above the aft engine room. Explosive decompression took care of our opposition.

The rest of the Interdictor's crewmembers were too busy with the battle to react to our little incursion. We pushed

past the drifting bodies and moved into the next room, sealed it, and shed our space suits. I took a deep, satisfied breath. Not being able to smell my surroundings is like going blind.

I popped the hatch and crawled inside the systems while the others stood guard. Sniffing the vent ports for ozone and nitric oxide, I traced the reactor governor by its electrostatic discharge and wired in our bypass.

The *Glaciate* sat dead in space. While the others commed Rieekan to tell him of our success, I peered out the porthole, down the length of the ship I'd just captured. Promotion, anyone? I like the sound of Captain Reetgeet!

PART III
THE NEW CONFLICT

IMPERIAL COMMANDERS FELL before Ackbar's armada. The Alliance fleet moved toward Coruscant, which was still the capital of the Empire despite its now empty throne. Other Alliance commanders scoured the Outer Rim for signs of Imperial admirals, generals, and moffs, hoping to disrupt any attempts at organizing a unified counterattack.

Mon Mothma issued a declaration formally establishing a New Republic and completing the Rebellion's transformation into a political power. As the news spread from the Core to the Rim, thousands of worlds petitioned for membership under the New Republic's flag.

One year after the Battle of Endor, a broken Empire had abandoned almost all of its former holdings. And after a devastating defeat at the Battle of Jakku, the Empire signed the Galactic Concordance and agreed to dismantle its military.

A once-mighty galactic power had been thoroughly humbled. The Empire had no emperor, no territory, and no influence. To uphold the new agreement and set itself apart from the old regime, the New Republic followed through with its own disarmament—despite rumors that an Imperial-inspired threat had taken root in the Unknown Regions.

This evolved into the First Order: a fanatical splinter faction manipulated by the enigmatic Supreme Leader Snoke. The First Order worshiped the history and iconography of Palpatine's Empire. As it grew in strength, hidden shipyards launched new First Order warships and starfighters. The frozen world called Starkiller Base became a planet-size superweapon.

General Leia Organa, a decorated veteran of the Rebellion, was one of the few who spoke out against the dangers of the First Order. When the New Republic denied military help, she formed her own volunteer militia. From a base on D'Qar, General Organa's Resistance harassed First Order targets and tried to determine Snoke's next move.

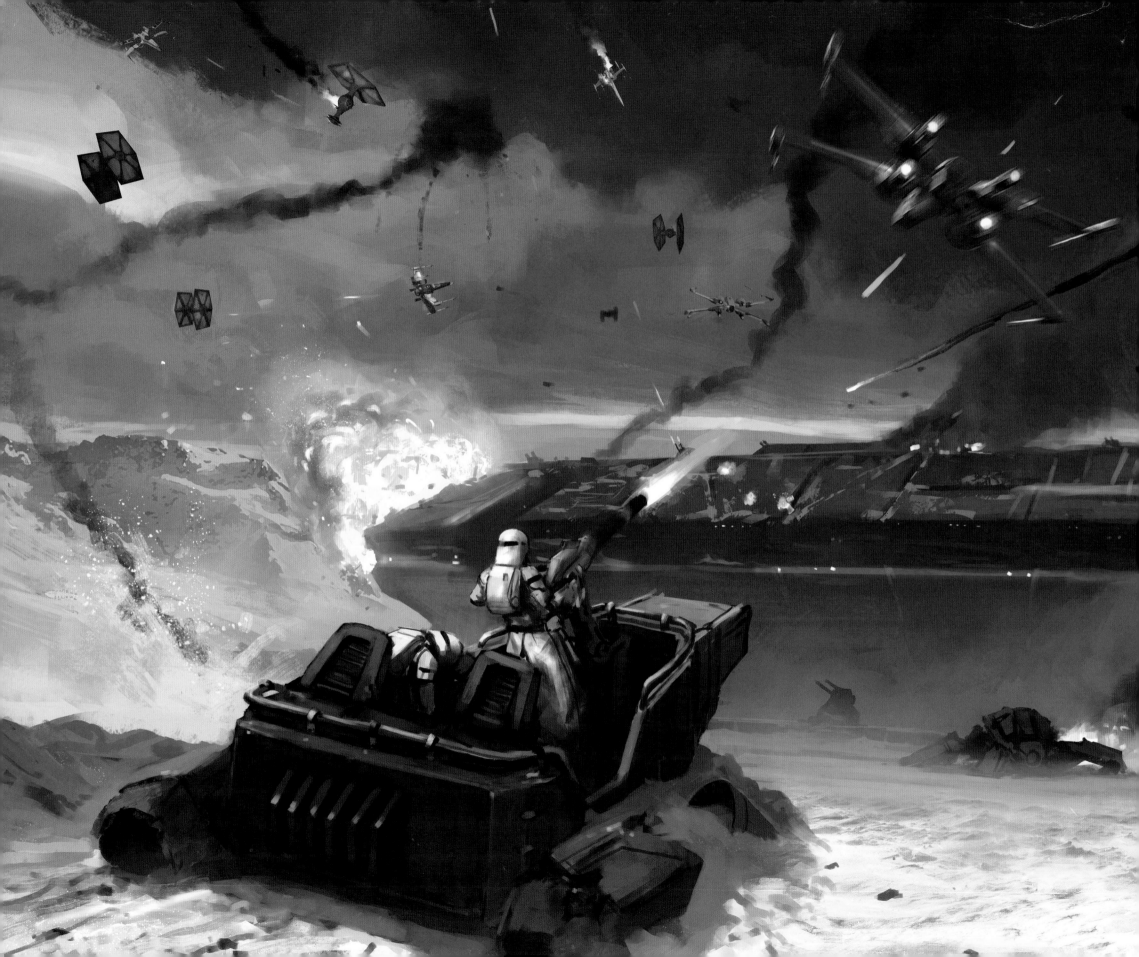

BATTLE ON STARKILLER BASE

- SKY -

No weapon as big as Starkiller Base had ever existed. The scale and scope of its destructive power could scarcely be imagined.

Built inside the core of a planet, the weapon drained stars of their energy and stored that energy to be released in a beam that could tear through sub-hyperspace at near-instantaneous speeds, destroying everything in its path. Anything the beam encountered—including mul-tiple planets in a star system—would be torn to atoms.

General Hux of the First Order selected the Hosnian system as the weapon's first target. The successful test obliterated five planets in a single shot, including the New Republic cap-ital of Hosnian Prime.

General Leia Organa and the Resistance traced the attack back to its source and dispatched a reconnaissance flight to verify Starkiller Base's location. The First Order did the same, tracking the return path of the recon fliers to the Resistance headquarters on D'Qar.

The Resistance knew Starkiller Base had to be neutralized or destroyed before it could strike again. If they did not succeed in doing so, its next target would almost certainly be D'Qar.

GENERAL LEIA ORGANA

Since she was a teen, Leia Organa served the Rebel Alliance as a fighter, strategist, and diplomat. When the New Republic would not grant her the military backing she desired to counter the growing threat of the First Order, she founded the volunteer forces of the Resistance.

PRELUDE TO BATTLE

With little time to strategize, the Resistance relied almost exclusively on testimony offered by Finn, a former First Order stormtrooper with incomplete knowledge of the Starkiller facility. Based on his information, the Resistance's plan began to take shape.

A ground team would land on the Starkiller surface in order to penetrate the base and disengage its shields. With the shields rendered ineffective, a contingent of Resistance X-wings could bomb the oscillator—a surface installation that maintained the integrity of Starkiller Base's containment core.

Han Solo and his copilot Chewbacca volunteered to bring Finn back to Starkiller Base aboard the *Millennium Falcon*. Their plan was to slip through the active planetary shield by dropping out of hyperspace below the shield but above the planet's surface—a maneuver requiring such precision that most dismissed it as an impossible feat.

TACTICAL ANALYSIS

After bringing the *Millennium Falcon* to a safe stop in the wake of its insanely risky hyperspace egress, Han Solo, Chewbacca, and Finn made their way to the nearby command installation. Armed with a sack of thermal charges, their intention was to bring down the planetary shields through sabotage.

Finn, familiar with the base's layout and command structure, proposed an alternate plan. His team lay in wait for Captain Phasma—chief officer of the First Order's Stormtrooper Corps—and coerced her into a computer annex. Phasma's rank meant that she possessed the command codes needed to bypass the network's system lockouts. A blaster to her head was enough to ensure her cooperation. Though Phasma complied in bringing down Starkiller Base's shields, she knew that the planetoid would not be unprotected for long. The very act of dropping the shields would, in fact, alert General Hux to the enemy's infiltration.

The Resistance, however, had planned its starfighter attack with precision and needed only a brief window for a successful insertion. Commander Poe Dameron, leading the Resistance X-wings, ordered his squadrons to execute a micro-jump. The ships emerged directly above Starkiller Base and plunged through the atmosphere to reach an elevation just above the forest tree line. Despite their speed, the First Order's scopes immediately registered the X-wings' arrival. On a command from General Hux, Starkiller Base scrambled its TIE fighters and powered up its heavy cannons.

Commander Dameron's X-wings drew into formation above the oscillator to make their first bombing run on its reinforced durasteel exterior. Multiple hits from proton torpedoes were ineffectual. They could not even crack its exterior shell. The X-wings swung around to make a second pass, but by then the air above the oscillator was lit up with turbolaser flashes and the snaking jet trails of homing missiles. Multiple TIE squadrons followed, selecting individual X-wings for elimination and stalking them with dogged persistence.

While Han Solo's ground team had succeeded in its mission to bring down Starkiller Base's shields, they could see that similar success for the X-wing fighters was in jeopardy. But because the ground mission had been completed without resorting to sabotage, the ground team still possessed a full complement of thermal charges. Once they saw that the Resistance X-wings were under attack, Solo decided to infiltrate the oscillator building and destroy its support columns.

By this point, the team of Solo, Chewbacca, and Finn had acquired a fourth member: Rey, a former desert scavenger who had freed herself from First Order custody.

After reaching the oscillator on foot, Rey and Finn hijacked a First Order snowspeeder and sped to a junction station to open the installation's heavy doors. Once inside, the team quickly planted its detonators. The resulting explosion shook the foundation of the oscillator, creating a gap in its top surface. From the air, Commander Dameron and the Resistance squadrons spotted their new entry point. The X-wings formed a run that would take them inside the oscillator itself, flying down an access trench that ended inside the structure's central mechanism.

Recognizing the danger, General Hux activated all ground cannons and ordered all surviving TIE fighters to disrupt the Resistance's attack run.

The X-wing squadrons suffered heavy losses, but Dameron succeeded in reaching the core. By immediately cutting his speed, Dameron made repeated shots at close range, inflicting massive damage to the sensitive workings of the oscillator. According to the Resistance's intelligence, a damaged oscillator would temporarily take Starkiller Base offline, buying the Resistance enough time to complete an evacuation of D'Qar.

Yet the timing of the attack could not have been more advantageous to the Resistance. By the time the X-wings emerged from hyperspace, General Hux had already begun the process of loading Starkiller Base with dark energy drained from a nearby star. This unimaginably powerful and volatile fuel source now churned within the heart of the planetoid—and, thanks to the damaged oscillator, the dark

energy could no longer be held in stasis. Starkiller Base began to consume itself from the inside out. The ground shook as the planetary crust fractured along fault lines.

Tragically, Han Solo lost his life to First Order enforcer Kylo Ren during the mission to sabotage the oscillator. However, Finn, Rey, and Chewbacca were able to escape aboard the *Millennium Falcon*. Poe Dameron and the surviving X-wings escorted the *Falcon* to safety as Starkiller Base exploded behind them.

The First Order had lost the battle, but most of its high-ranking officers had fled the base prior to its destruction. General Hux, Kylo Ren, and Captain Phasma were all among those who escaped Starkiller Base's fate to regroup in the Unknown Regions to fight another day.

> ## "DESPITE THEIR SPEED, THE FIRST ORDER'S SCOPES IMMEDIATELY REGISTERED THE X-WINGS' ARRIVAL."

AFTERMATH

The First Order lost its headquarters and its superweapon. More significantly, the galaxy now views the Imperialists as a murderous and imminent threat.

The decades spent in the shadows are over. No more can the First Order build its army and navy without fear of reprisal. Everyone—not just General Organa's Resistance—knows what they are facing.

The New Republic is no more. When its politicians perished on Hosnian Prime, its authority collapsed into a leaderless vacuum.

The future once again hinges on a frontline clash between ideologies, and it is not just soldiers who will suffer. History does not yet know who will triumph in the war between the Resistance and the First Order, but the battles still to be fought will determine the fate of the galaxy.

GENERAL ARMITAGE HUX

Hux lived his entire life within the First Order, rising to command its military forces based largely on nepotism and his tactical scores in warfare simulations. He had no actual battle experience.

COMBATANTS

1 **FIRST ORDER TIE FIGHTER PILOTS:** The members of the First Order's piloting corps flew upgraded TIE starfighters. Prior to the Battle of Starkiller Base, most of their flight time had been logged in simulators.

2 **RESISTANCE PILOTS:** The volunteers that made up the ranks of the Resistance Starfighter Corps believed that only their vigilance could stop the spread of the First Order. Most of them flew T-70 X-wing star-fighters.

3 **FIRST ORDER STORMTROOPERS:** Conscripted into service at an early age, First Order stormtroopers were rigorously trained and indoctrinated into a culture of conformity. They were known only by their serial numbers.

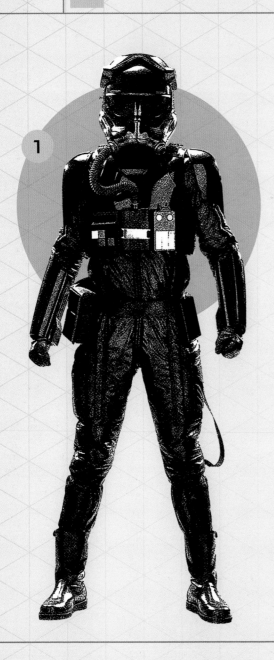
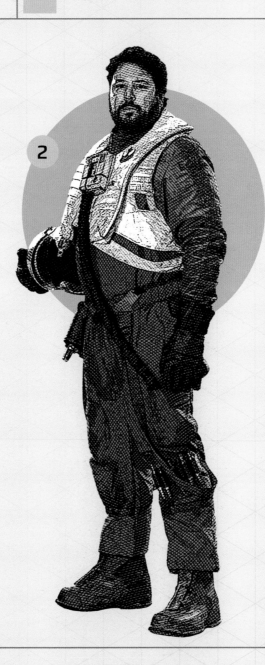
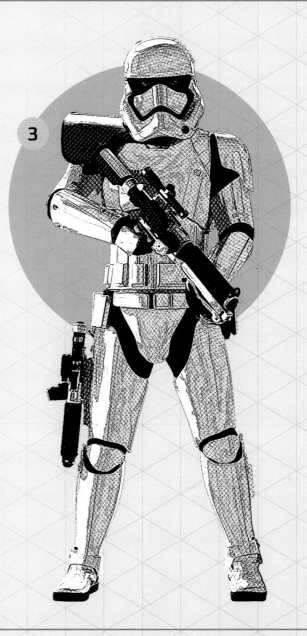

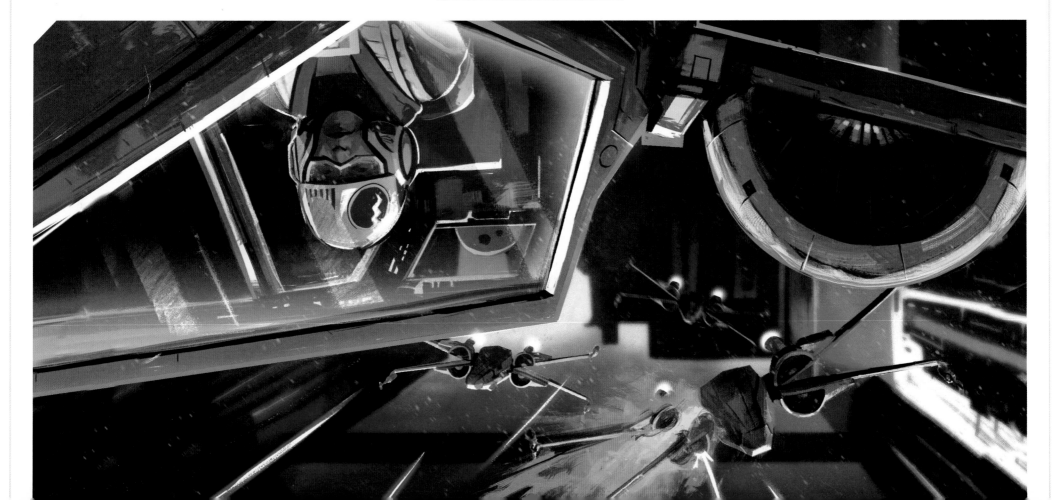

I WAS THERE

Jess "Testor" Pava (Blue Three)

Talk about heroes of the Rebel Alliance and Luke Skywalker gets brought up a lot. But all anybody talks about is the Force, or lightsabers, or the Jedi. That's not how I think of Luke Skywalker. In my eyes, he's the best X-wing pilot of all time. And if I'm not yet the second best, I will be soon.

Like Luke, I grew up on a planet nobody cared about, where I taught myself to fly in a banged-up airspeeder. It forces you to develop a gut feel for three-dimensional space, a survival necessity when your cheap instrumentation won't tell you what you need to know. It's that ability that helped me stomp the First Order on the mission to Starkiller Base.

We didn't have much time to prepare. And just like the Death Star mission, we were operating under a countdown.

In that battle, Luke used canyon-running tactics to zoom down the trenches at full throttle. I knew I could do the same thing, but with one huge advantage: a deliciously thick and choppy atmosphere.

The Death Star had been surrounded by hard vacuum, where the Empire's TIEs had the best possible environment for evenly matched dogfights. But skies above Starkiller Base? I knew those air currents were going to play all kinds of havoc wherever those huge TIE panels caught a stiff wind. And I was willing to bet that the TIE pilots didn't have the brains or the instinct to compensate.

I was right—at least about the TIEs. But Starkiller Base had ground cannons too. They fired homing missiles, and we lost some good pilots. But when the TIE squadrons closed in, the Resistance got the upper hand.

The S-foils on an X-wing are basically *designed* for atmospheric flight! Ease off on the repulsors and just let the thermals and crosswinds lift you, flip you, and drop you. It was like I was back in my Skipfish running the Dandoran Eyeteeth. I didn't have to calculate, I just *knew*.

Given enough time, we could have cleared the skies, but destroying the oscillator was priority. Commander Dameron took the kill shot, but I blew the TIEs off his tail. Starkiller Base exploded a hundred times bigger and brighter than the Death Star.

I dare the First Order to build another superweapon. I can't wait to paint another kill tally on the nose of my X-wing.

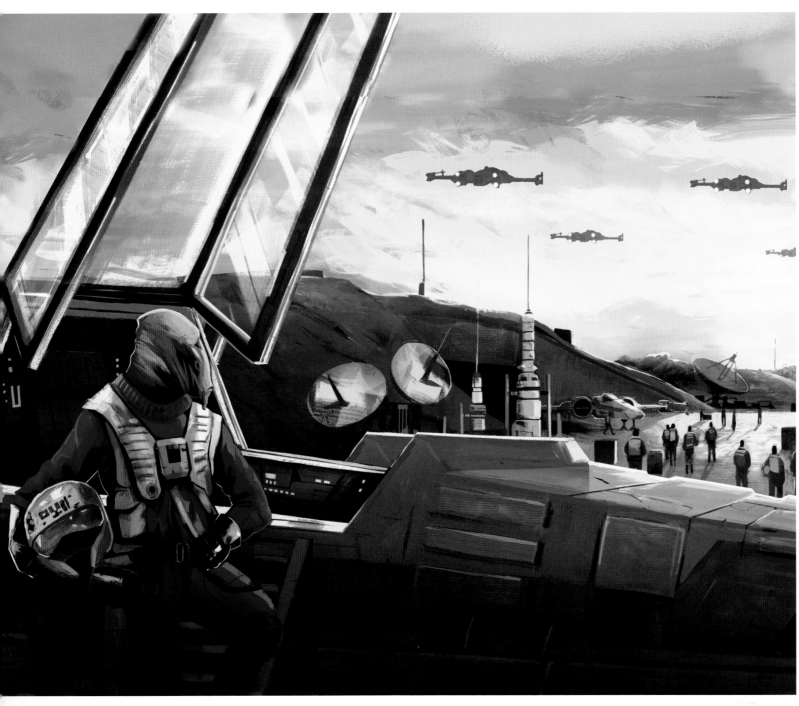

Ello Asty

Prior to the Battle of Starkiller Base, Abednedo pilot Ello Asty had logged the highest ratio of combat minutes to total flight time than any other pilot in the Resistance. Notorious for his "shoot first, investigate second" attitude and an unfailing nose for trouble, Asty scorned caution in his zeal to destroy First Order convoys and picket squads.

Asty followed Poe Dameron's lead as the squadrons approached Starkiller Base, but the instant he received the order to engage he dropped his X-wing to a terrain-hugging elevation, taking target practice to disable heavy cannons as they rose from the snow. The AT-PD walkers that ringed the oscillator's perimeter also fell under Asty's assault, as his surgical laser strikes blew off heads and melted leg joints.

In one notable act of heroism, Asty flew between Blue Nine and a pair of homing missiles that had locked on to Nine's X-wing's engine signature. After the missiles recalibrated to target Asty, he led them down to the surface, where they exploded harmlessly against a canyon's rim.

When the Resistance pilots made their final bombing run on the oscillator, Asty provided cover for the lead ships. With little room to maneuver inside the tight confines of the channel, he fell prey to a homing missile that overtook his X-wing from behind.

TOOLS OF WAR

1 **FIRST ORDER TIE FIGHTER:** The TIE/fo space superiority starfighter appeared similar to those used by the former Empire, but the solar-collecting wing panels allowed more energy to reach the reactor. First Order TIEs could fly faster and operate for longer stretches of time without refueling.

2 **T-70 X-WING FIGHTER:** The Resistance T-70 X-wing starfighter resembled the old Rebel Alliance T-65 X-wing, but with semicircle engines built directly into its split wings. The T-70's secondary weapons pod allowed pilots to replace the proton torpedo launcher with a heavy laser cannon.

3 **FIRST ORDER SNOWSPEEDER:** The First Order's LIUV, or Light Infantry Utility Vehicle, was an armored repulsorlift craft outfitted for the chilly temperatures of Starkiller Base. It was armed with a single forward-facing blaster cannon.

4 **AT-PD:** The First Order's All Terrain Patrol Droid was produced in small numbers and deployed across Starkiller Base to guard sensitive installations. Its head housed generators that powered its two heavy-laser cannons.

5 **ANTIAIRCRAFT CANNONS:** The ridges and flood trenches of Starkiller Base were lined with heavy cannons capable of firing both lasers and homing missiles. Stormtrooper crews handled the tasks of aiming, firing, and reloading.

6 **STARKILLER BASE:** With machinery that filled the core of a small planet, Starkiller Base was the largest weapon of war ever constructed. Its ability to fire phantom energy through sub-hyperspace placed every world in the galaxy at risk.

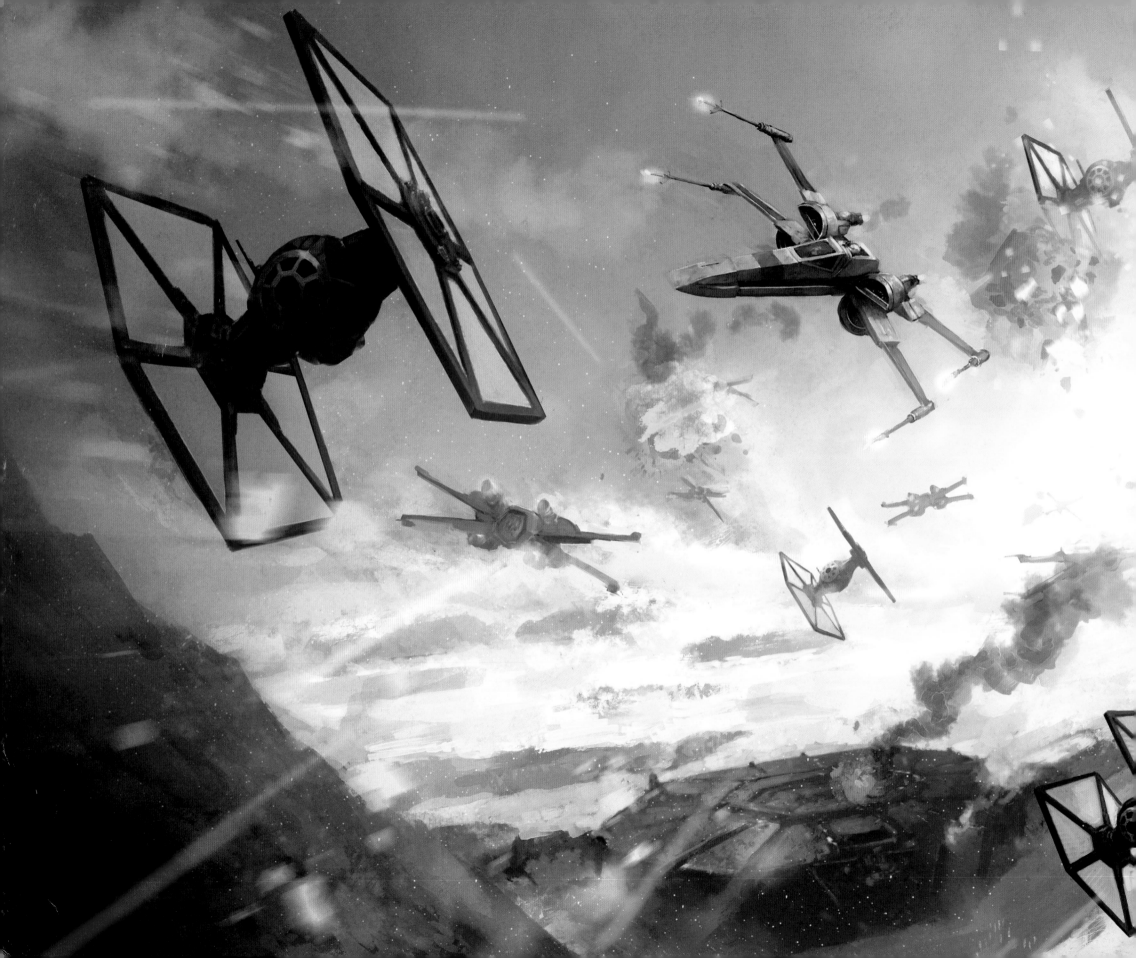

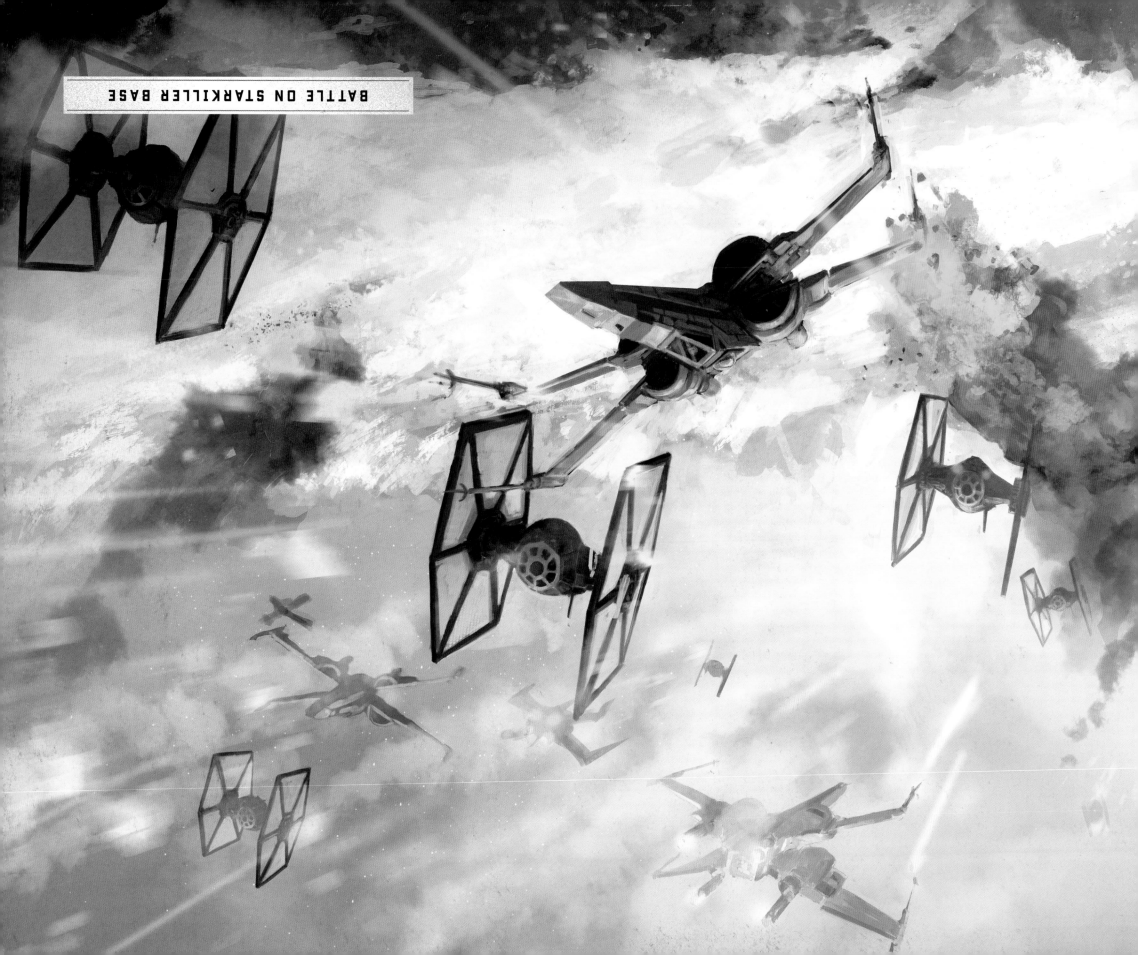

TIMELINE OF BATTLES

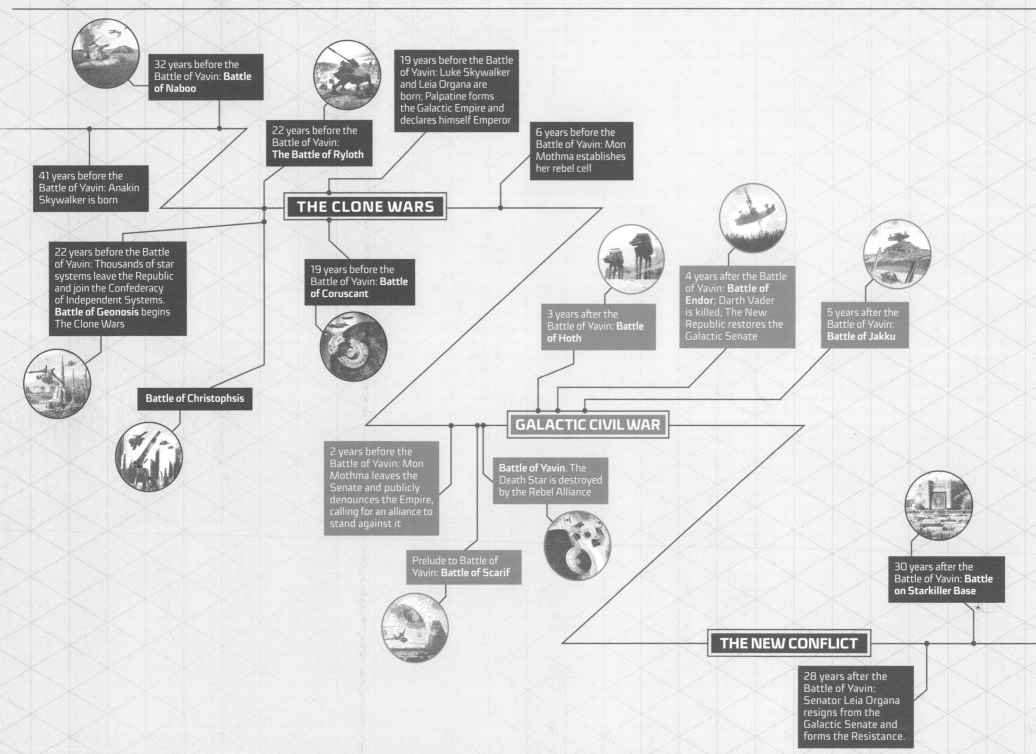

32 years before the Battle of Yavin: **Battle of Naboo**

19 years before the Battle of Yavin: Luke Skywalker and Leia Organa are born; Palpatine forms the Galactic Empire and declares himself Emperor

22 years before the Battle of Yavin: **The Battle of Ryloth**

6 years before the Battle of Yavin: Mon Mothma establishes her rebel cell

41 years before the Battle of Yavin: Anakin Skywalker is born

THE CLONE WARS

22 years before the Battle of Yavin: Thousands of star systems leave the Republic and join the Confederacy of Independent Systems. **Battle of Geonosis** begins The Clone Wars

19 years before the Battle of Yavin: **Battle of Coruscant**

4 years after the Battle of Yavin: **Battle of Endor**; Darth Vader is killed; The New Republic restores the Galactic Senate

3 years after the Battle of Yavin: **Battle of Hoth**

5 years after the Battle of Yavin: **Battle of Jakku**

Battle of Christophsis

GALACTIC CIVIL WAR

2 years before the Battle of Yavin: Mon Mothma leaves the Senate and publicly denounces the Empire, calling for an alliance to stand against it

Battle of Yavin. The Death Star is destroyed by the Rebel Alliance

Prelude to Battle of Yavin: **Battle of Scarif**

30 years after the Battle of Yavin: **Battle on Starkiller Base**

THE NEW CONFLICT

28 years after the Battle of Yavin: Senator Leia Organa resigns from the Galactic Senate and forms the Resistance.

ACKNOWLEDGMENTS

Special thanks to artists Adrián Rodriguez, Thomas Wievegg, Aaron Riley, and Fares Maese; editor Delia Greve, designer Sam Dawson, and production coordinator Olivia Holmes at becker&mayer; and Lucasfilm's Brett Rector, Frank Parisi, Erik Sanchez, Bryce Pinkos, Tim Mapp, Shanana Alam, and the Lucasfilm Story Group.

AUTHOR BIO

Daniel Wallace is a comic book expert, sci-fi sage, and lifelong geek. Author or coauthor of more than two dozen books including *Star Wars: The Jedi Path*, *Ghostbusters: The Ultimate Visual History*, *The World According to Spider-Man*, *Warcraft: Behind the Dark Portal*, and the *New York Times* best-selling *Star Wars: The New Essential Guide to Characters*, his specialty is exploring the underpinnings of popular fictional universes.

Library of Congress Cataloging-in-Publication Data:

ISBN: 978-1785652141

Star Wars: On the Front Lines is published by Titan Books
A division of Titan Publishing Group Ltd.
144 Southwark St.,
London, SE1 0UP
www.titanbooks.com

Produced by becker&mayer!, an imprint of Quarto Group USA
Bellevue, Washington.
www.QuartoKnows.com

Edited by Delia Greve
Designed by Sam Dawson
Production coordination by Tom Miller and Olivia Holmes

Manufactured in China

Written by Daniel Wallace

Illustrations by:
Adrián Rodriguez: p. 15, 16, 23, 24, 34, 35, 46, 47, 55, 56, 63, 64, 75, 76, 83, 84, 96, 97, 98, 112, 113, 121, 122

Thomas Wievegg: p. 10, 18, 28, 40, 50, 70, 78, 88, 106, 116

Aaron Riley: p. 12, 13, 20, 21, 30, 31, 42, 43, 44, 52, 53, 60, 61, 72, 73, 80, 81, 90, 91, 92, 93, 108, 109, 118, 119

Fares Maese: p. 26–27, 38–39, 66–67, 86–87, 102–103, 124–125

10 9 8 7 6 5 4 3 2 1

Did you enjoy this book? We love to hear from our readers.
Please e-mail us at: readerfeedback@titanemail.com
Or write to Reader Feedback at the above address.

15638